COLOUR AND LINE IN
WATERCOLOUR

Glen Scouller

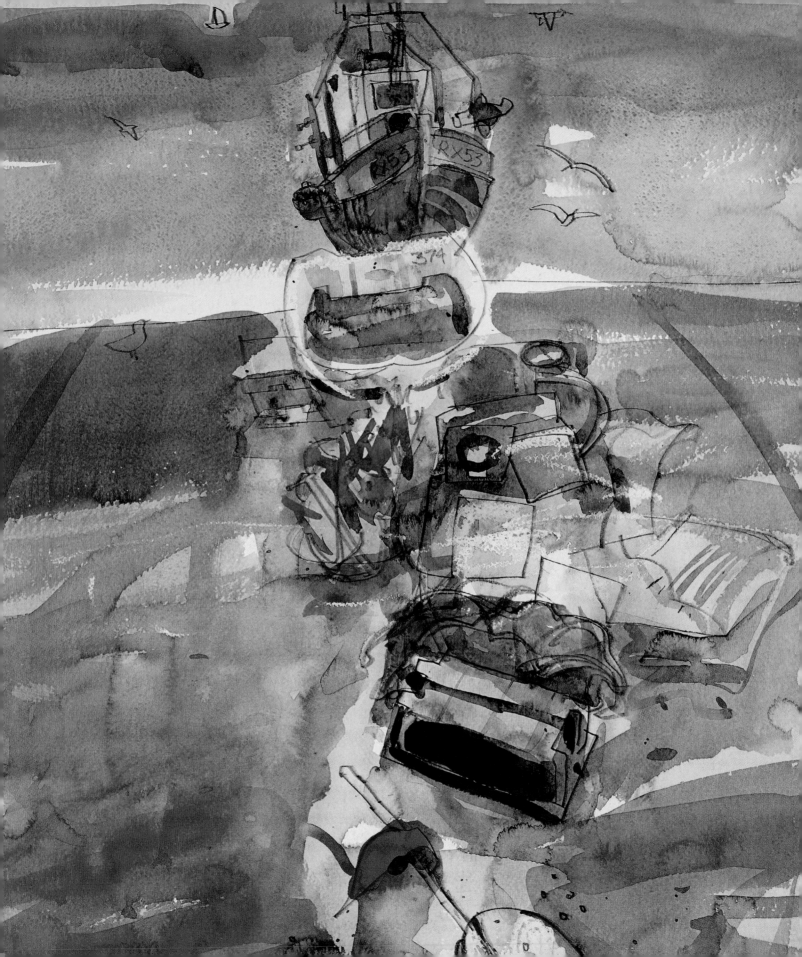

COLOUR AND LINE IN
WATERCOLOUR

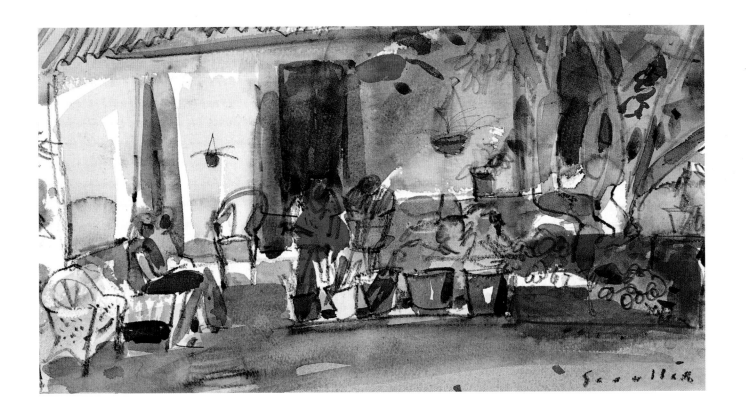

Glen Scouller

BATSFORD

For Carol, Kim and Lara.

First published in the United
Kingdom in 2016 by
Batsford
1 Gower Street
London
WC1E 6HD

An imprint of Pavilion Books
Group Ltd

Illustrations and text copyright ©
Glen Scouller, 2016
Volume copyright © Batsford, 2016

ISBN: 9781849943123

A CIP catalogue record for this book
is available from the
British Library.

10 9 8 7 6 5 4 3 2 1

Repro by Rival Colour UK
Printed by 1010 Printing
International Ltd, China

This book can be ordered direct
from the publisher at the website:
www.pavilionbooks.com, or try your
local bookshop.

Page 2
**Boat and Fishing Paraphernalia,
Hastings**
*Watercolour, Berol Karismacolor water-
soluble pencil, oil pastels, Waterford NOT
paper, 71 x 53 cm (28 x 21 in.) Collection
of the artist*

Page 3
The Conversation, Falacho, Portugal
*Watercolour, Berol Karismacolor water-
soluble pencil, white oil pastel, Waterford
NOT paper, 23 x 42 cm (9 x 16½ in.)
Private collection*

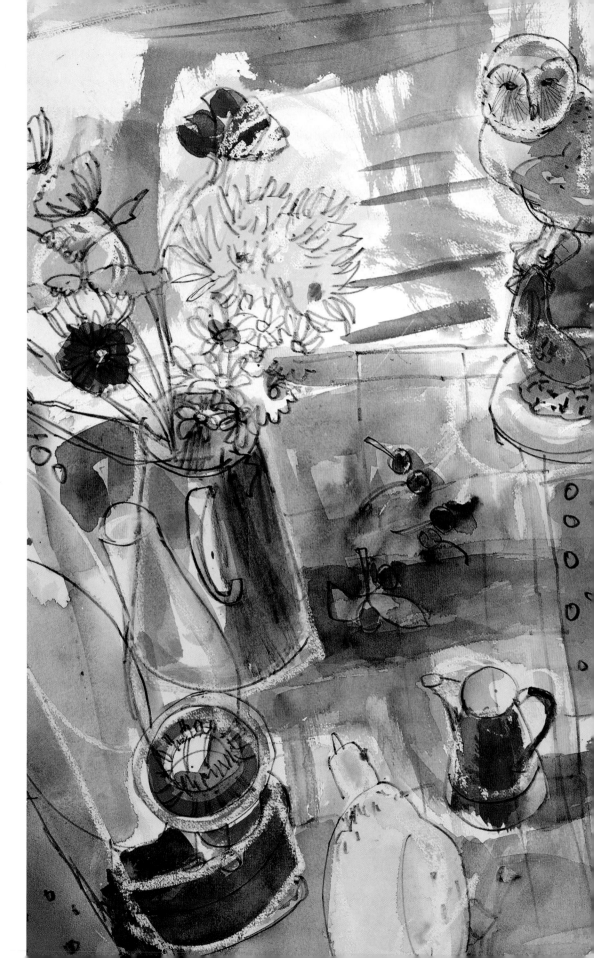

Contents

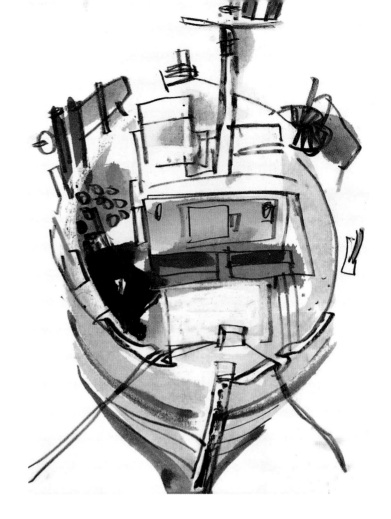

Left
The Pink Cloth'
Watercolour, Watercolour, Berol Karismacolor water-soluble pencil, Waterford NOT paper, white oil pastel, 71 x 53 cm (28 x 21 in.) Collection of the artist

Above, right
Small Boat, Sicily
Paolo Olbi handmade, leather-bound watercolour sketchbook, watercolour, white oil pastel, water soluble pencil 23 x 30 cm (9 x 12 in.) Collection of the artist

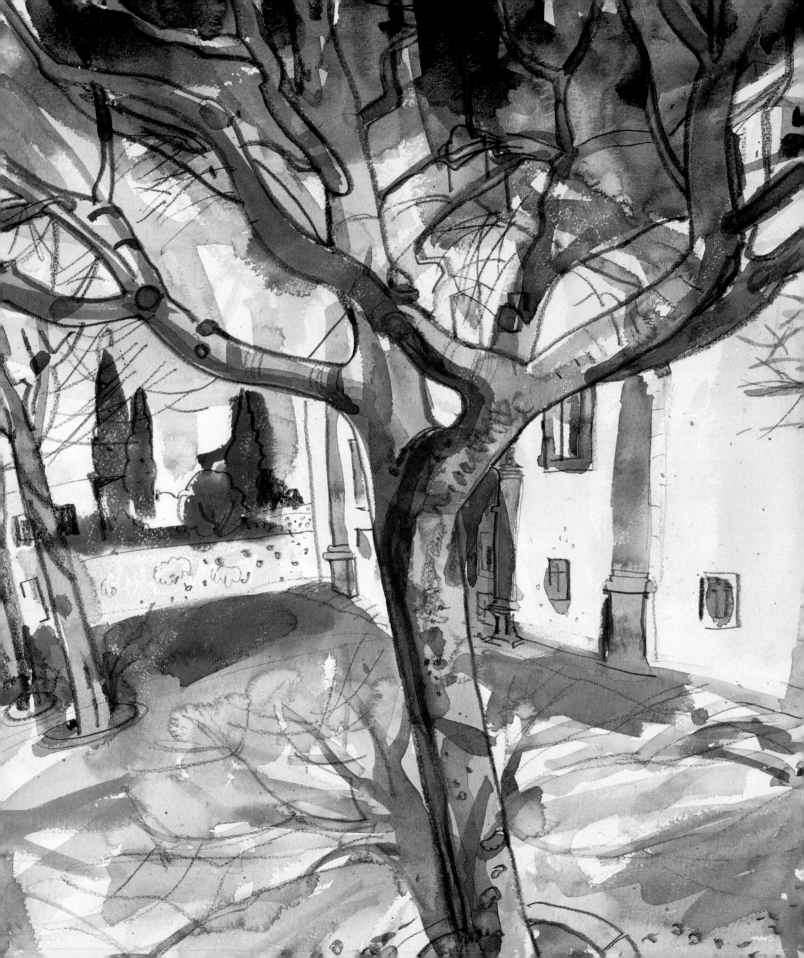

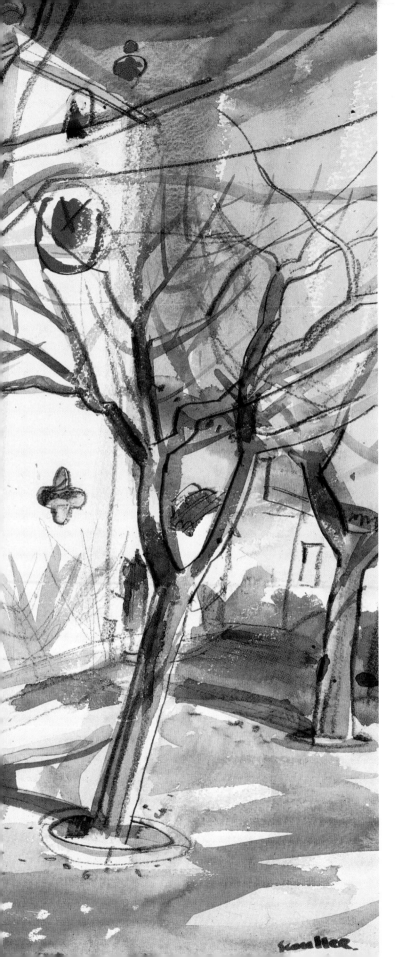

Introduction

Watercolour is a swim in the metaphysics of life... a mirror of one's own character. Let it be unpredictable and colourful.

Anonymous

The mere mention of watercolours to some contemporary artists is often met with a reaction of derision and disdain: in their eyes, the medium is in the bracket of the 'hobby artist' or 'Sunday painter'. This is despite the fact that the use of watercolour was firmly established in British painting history by eighteenth-century and nineteenth-century English artists such as Turner (1775–1851), Cotman (1782–1842), Sandby (1731–1809) and their contemporaries. The rise of watercolour painting was also tied to a growing acceptance in Britain of 'landscape' as an appropriate subject for painting. The use of watercolours by these pioneering artists had a truly liberating effect on the nature of art for future generations. Artists now had a medium that was easily transportable, and there was no need to carry around easels, canvases or other heavy equipment. They were no longer tied to creating art within the four walls of a studio: the whole world opened up as a studio.

The Church, Mexilhoeira Grande, Algarve, Portugal

Watercolour, pencil and oil pastels, Waterford 300 gsm NOT paper
53 x 71 cm (21 x 28 in.) Private collection
A strange thing happens when I can't get far enough back from my subject, and this beautiful old Portuguese church, with its trees stripped of their leaves in winter, is a typical example. The verticals appear to be distorted as if seen through a fish-eye lens. This is not something I do consciously: it just seems to happen naturally in my attempt to 'fit' everything I want into the picture, but I rather like the dynamic effect it has on the composition.

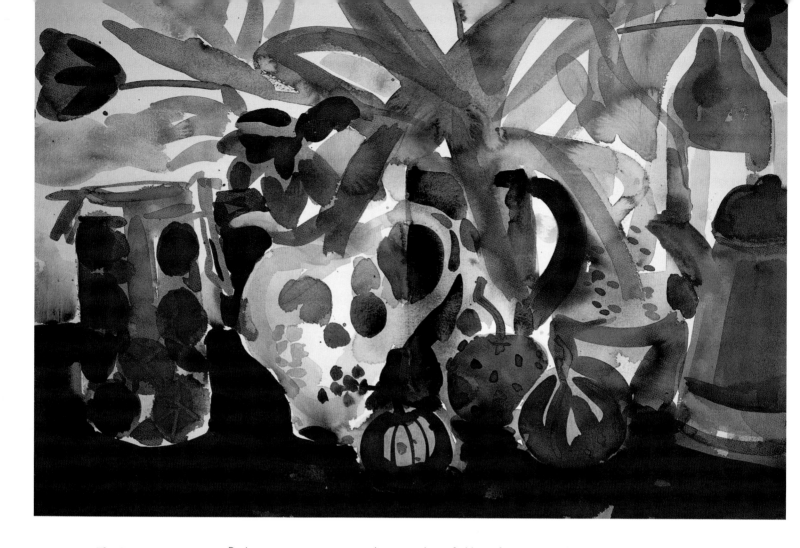

The Spongeware Jug

Watercolour, Waterford 300 gsm
NOT paper 53 x 71 cm (21 x 28 in.)
Private collection

This is an example of an early watercolour where the sumptuous colour and pattern made by the objects' grouping was what charmed me. There is no under-drawing involved: here I simply relied on all my senses and got straight into the colour washes and mark-making, firstly with a large mop brush. Then, with a smaller brush, I added dots of pattern where they appeared on the jug and various bits of exotic fruit.

By its very nature, watercolour can be a fickle, infuriating and elusive medium, where mistakes are difficult to remedy and the applied colour sometimes appears to have a mind of its own. This, however, is one of the things I like about watercolour – its unpredictable nature and the need to 'go with the flow' when using it. Accidents happen... and marks, blobs, dribbles, spatters etc. can all be exciting if successfully fused into a painting. David Hockney is quoted as saying that you can't cover up mistakes, and there is an element of truth in that statement, but only if you are making watercolours in a very purist, traditional manner. I prefer to take an approach that says if it works... then anything goes. But perhaps not to the extremes of Francis Bacon, who mused: 'I use all sorts of things to work with: old brooms, old sweaters, and all kinds of peculiar tools and materials.' He was, of course, referring to his oil paintings, so maybe that approach is not best suited to watercolour painting – but who knows, I've never tried such methods!

To achieve a truly successful watercolour painting is a bit of a balancing act. On the one hand, you have the aqueous pigment wanting to go its own way, and on the other hand, you must have a certain degree of control. Getting this delicate balance right is difficult, but the results can be magical. No other medium possesses the limpid quality of watercolour, where transparent washes appear to float on the paper.

The discipline of working from life

If you are not skilful enough to sketch a man jumping out of a window in the time it takes him to fall from the fourth storey to the ground, you will never be able to produce great works.

Eugène Delacroix (1798–1863)

In the late 1960s and early 1970s I received a fairly classical training in drawing and painting at Glasgow School of Art, with the emphasis firmly on drawing from the life model. This disciplined way of working has stood me in good stead throughout my professional career.

Drawing has always been important to me and it's something I enjoy doing on an almost daily basis. Sadly, nowadays art schools have moved away from this tried and tested method of training and I strongly feel that today's students are missing out. Today the emphasis is more on intellectual input from the student rather than the physical, practical act of doing: they are asked to write about a still life rather than paint it; take a photo of a nude rather than draw it. I ask myself when the course directors will acknowledge that learning the core essentials of hand–eye observation/coordination is essential and will make a better artist, no matter what future route the student decides to pursue within the broad spectrum of the visual arts. Of course the sad thing is that a lot (if not most) of the tutors employed nowadays at art school level have themselves never received or have never had an interest in the core elements of drawing and painting, probably dismissing it as too old-fashioned and not fashionably cutting edge!

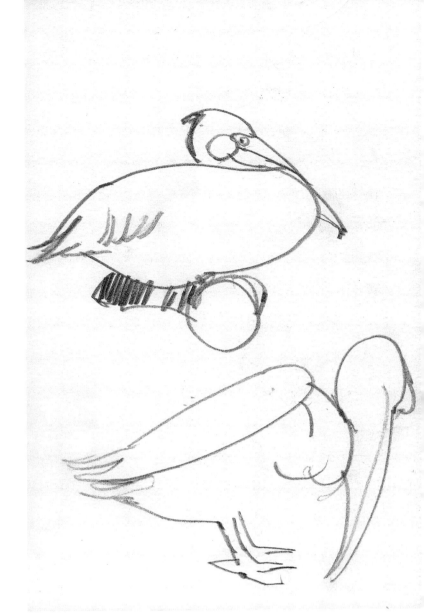

Pelicans, London Zoo
Staedtler clutch pencil with 4B lead, Hahnemühle sketchbook 297 x 210 cm (11¾ x 8¼ in.) Collection of the artist
Animals are nearly always on the move and it is challenging to try and capture something of their character, as with the pelican. Its beautiful, elegant shape reminded me of a Gaudier-Brzeska sculpture. These are two of many sketches I did at London Zoo, where these particular two birds obliged me by not moving too much!

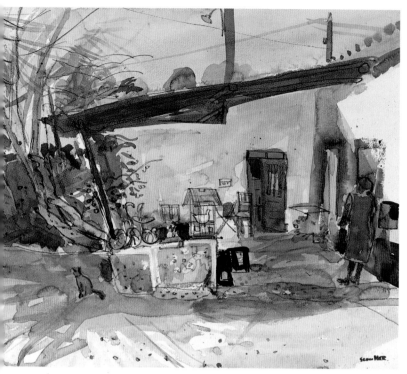

Bird and Cat, Falacho, Algarve, Portugal

Watercolour, Berol Karismacolor water-soluble pencil, oil pastels, Waterford 300 gsm NOT paper 53 x 71 cm (21 x 28 in.) Private collection

Again, because I couldn't get far enough away from the scene I wanted to paint, the trees and objects towards the edges of the composition have become more acutely angled. As the winter light was changing rapidly, I firstly blocked in all the main shadow areas with a mixture of French ultramarine and alizarin crimson, adding a few touches of white oil pastel to retain white on the dove and whitewashed wall. I then drew into certain areas with my pencil and picked out a few branches on the trees with a smaller brush.

I have always admired artists who can draw with pure line, such as Henri Matisse (1869–1954), Egon Schiele (1890–1918), Henri Gaudier-Brzeska (1891–1915), Raoul Dufy (1877–1953), Auguste Rodin (1840–1917), Ben Nicholson (1894–1984) and Joan Eardley (1921–1963); also some who taught me at art school, including Alexander Goudie (1933–2004), Duncan Shanks (b. 1937) and Leon Morrocco (b. 1942). They all realized the importance of line as a means of expression and for me, they all have one thing in common – the ease by which they can describe form and volume by means of a simple outline.

The combination of line and colour is something I have developed in my watercolour painting over the years. My early watercolours were made with no under- or over-drawing, just pure watercolour. This progressed into a desire to take them a stage further, experimenting by using various drawing materials in the process of making the finished painting. No matter which medium I use – whether it is oil, watercolour, pastel or gouache – I have always tried to bring out the best in my materials and I truly love the magical process of painting, which for me has always been an emotional and spontaneous thing tackled with all the intensity and passion that I can muster.

This book is therefore not so much a 'how to do it guide' – a book that explains how to paint a sky in three easy steps – but rather a 'how I did it book' – whereby the reader might find something interesting, stimulating and informative in my adventures, approach and methods with the wonderful medium of watercolour.

Beach Figures, Collioure

Pentel fibre-tipped pen, Moleskine sketchbook, 297 x 210 cm (11¾ x 8¼ in.)

Collection of the artist

This is detail from a small sketchbook, which because of its size, enabled me to draw inconspicuously on a fairly busy beach. With just a pen and notebook you can easily blend in, and draw the human figure close up.

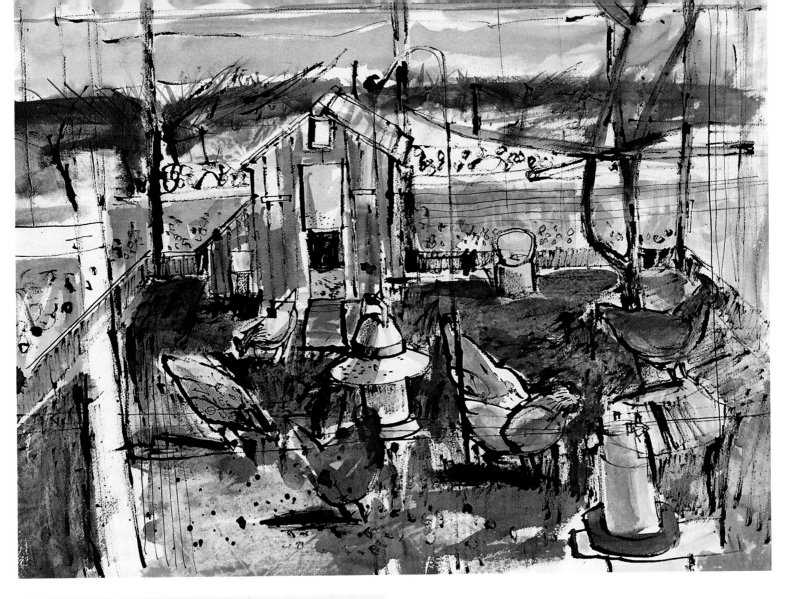

Hen Run, Winter

Watercolour, Indian ink, blotting paper, dry twig, Waterford 300 gsm NOT paper
53 x 71 cm (21 x 28 in.) Collection of the artist

This was a bit of an experiment: drawing into the preliminary colour washes with a sharpened dry twig dipped in Indian ink. I had used a bamboo pen many times before for ink drawings and enjoyed it, but never a dry twig. It demonstrates the fact that drawing is about mark-making, and any item that can hold a liquid medium or make a mark can be used to draw with. I also used a sheet of blotting paper to soak up the excess puddles of colour on the paper and created some interesting areas of texture. This was painted on a freezing cold winter's day, when the washes were taking ages to dry, so blotting paper (which I always take with me) came in very useful.

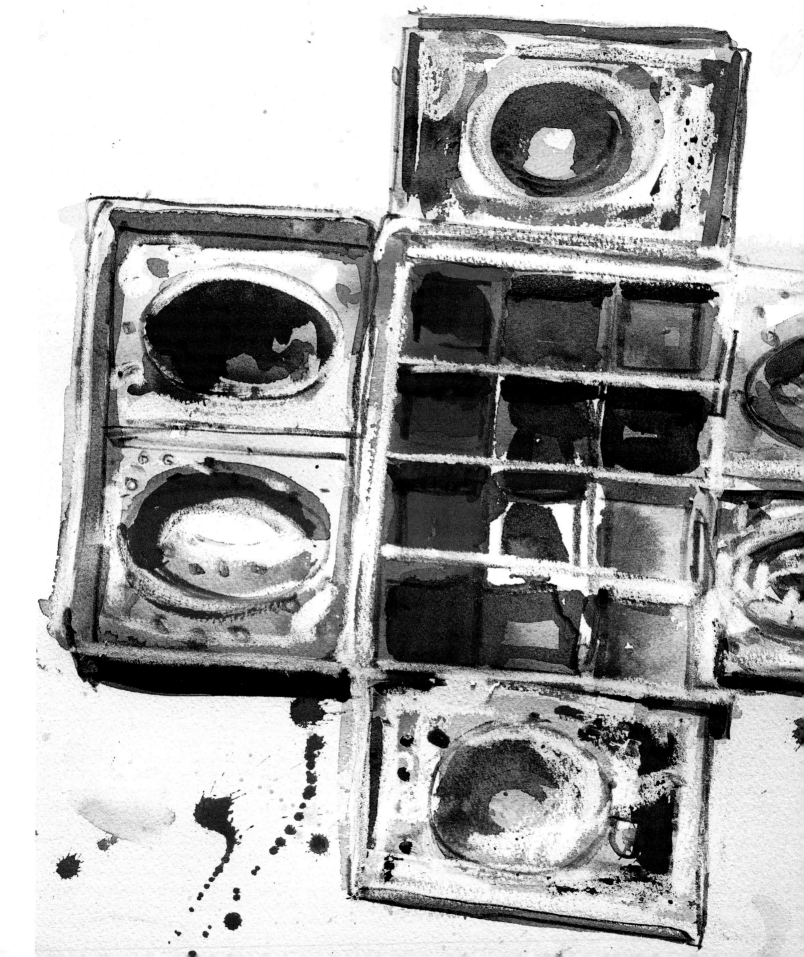

Basic tools, papers and surfaces

The hand is the tool of tools.

Aristotle (384–322 BC)

An artist's tools are his or her best friends. If you look after your tools, they should last a lifetime; abuse them, and they will need to be replaced regularly. This particularly applies to brushes for watercolour painting – for instance, a Kolinsky sable brush can cost hundreds of pounds. I have to hold my hand up and say that I have been guilty of mistreating brushes in the past, especially if I'm working outside and in full flow – so engrossed and connected with my subject that everything else appears not to exist. My sins include leaving brushes in buckets of water for too long a period, causing the varnished handle to crack and loosen, and eventually revert to bare, blackened wood!

My New Watercolour Box
Watercolour, Berol Karismacolor water-soluble pencil, oil pastels, Waterford 300 gsm NOT paper
41 x 39½ cm (16 x 15½ in.) Collection of the artist
This is a quick, splashy painting of a new paintbox, which I bought from the Little Brass Box Company. John Hurtley, the owner, makes them from brass to each individual's requirements, offering a number of basic designs that can be personalized to fit your needs. You can have it painted in one of six basic colours, or for a small extra charge have it rendered in almost any colour that takes your fancy. I chose to have mine kept as natural brass. It's a beautiful object both to look at and to paint with.

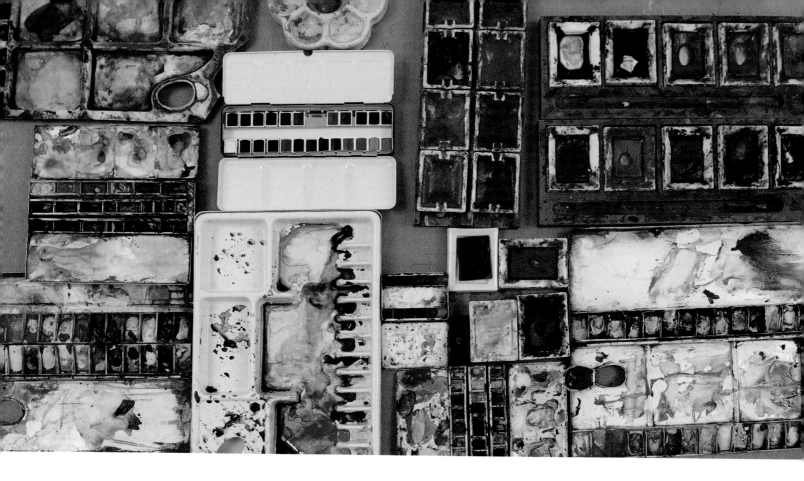

My brushes

This photograph shows a selection of the brushes I use. If I were asked to choose which brushes were indispensible I would say the large mop, the Escoda Kolinsky sable and a small sable. With these three brushes – small, medium and large – anything is possible.

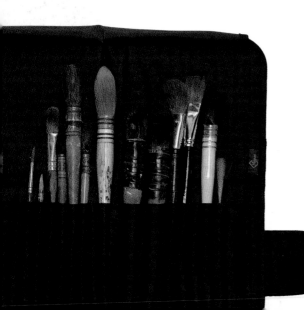

Brush care

A few useful tips worth remembering are:

- *Never store wet brushes in a sealed container, as they will be prone to attracting mildew.*

- *Always shape a brush after use (especially sables) and allow to dry naturally in the open air, or dry them with kitchen roll.*

- *Give brushes a treat once a year and use hair conditioner on them (a few drops per brush): allow it to soak in, then rinse before storing them. This should greatly enhance the performance of the brush – again especially noticeable with expensive sables.*

Palettes

The different watercolour palettes I've used over the years range from small, pocket-sized boxes to large ceramic pans set in wood – these are made by Winsor & Newton and Blockx in Belgium, and are great for working on a large scale with big brushes.

Siesta, Collioure, France

Watercolour, 6B pencil, Saunders Waterford sketchbook with 300 gsm NOT paper 26 x 29½ cm (10 x 11½ in.) Collection of the artist
I enjoy painting my family, who are sometimes reluctant models! However, on this occasion they were all so exhausted – due to too much exposure to the Mediterranean sunshine – that they were glad to have a nap and made perfect models. The colour of the sofa appeared to change as the sun moved during the course of the day, from shades of pink to mauve.

There are some artists who use a cheap, squirrel-hair brush for mixing colour and an expensive sable brush to apply the colour to their paintings. That is fine if you work in a slow, deliberate manner, but for me that would disrupt my work flow and not contribute to the spontaneity that I strive for in my work.

The way that you transport brushes is also important, as they can be easily damaged if just thrown in a bag. I have tried various solutions over the years, including (in the early days) tin tubes, plastic boxes and canvas bags; however, I have discovered that the best solution is either a bamboo brush roll or a brush wallet that also functions as a stand – for easy access to that elusive brush you are searching for when in full flow.

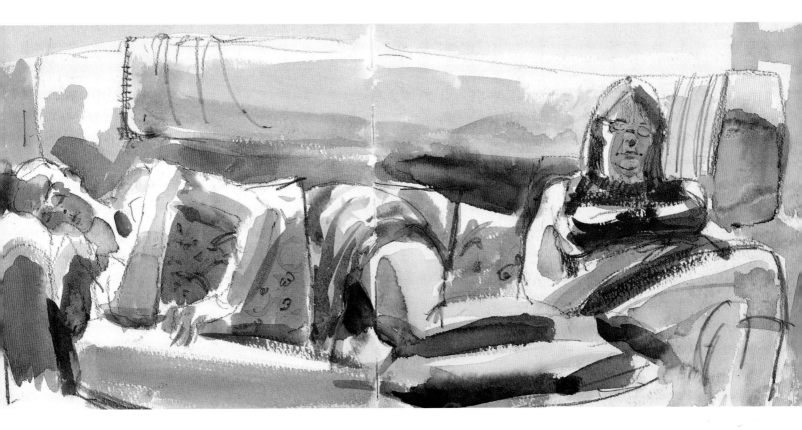

Harbour and Houses, St Abbs

Watercolour, 3B pencil, Saunders Waterford sketchbook with 300 gsm NOT paper 26 x 29½ cm (10 x 11½ in.) Collection of the artist
I painted this work and many others of St Abbs with a view to making some larger oils back in the studio. I wasn't after a photographic record of what I saw, just a note of what seemed important. I liked the ramshackle feel of the harbour, with all of the usual fishing sundries lying around; boats constantly bobbing about in the water contrasted with the fishermen's houses in the background. This sketch is very much in an unfinished state, but I felt it captured something of the atmosphere of the place. It was drawn lightly with pencil, then layers of colour washes were added on top.

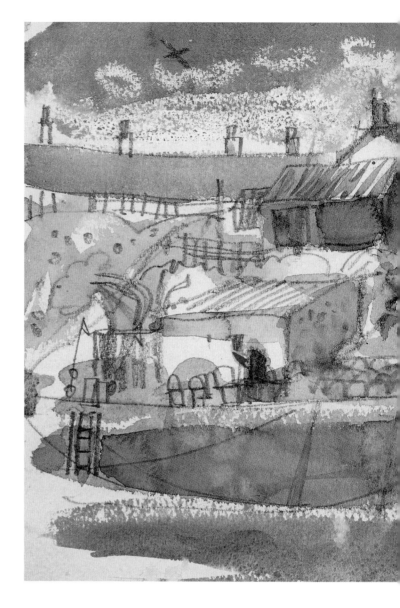

Pencil case

This pencil case is a recent addition to my travel kit. Both images picture the same wallet, which has two zipped compartments and can accommodate up to 64 pens and pencils. I find this easier than poking about in a pencil case trying to find something.

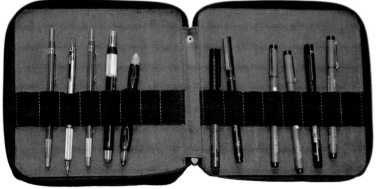
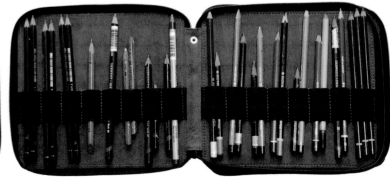

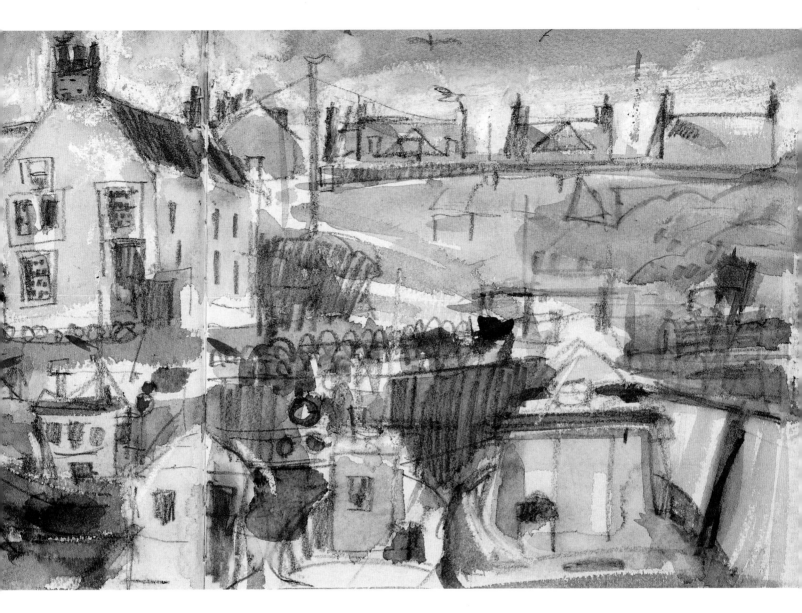

The type of paper you use depends on your working methods and the type of effect you are striving for in a painting. I personally prefer a NOT surface (cold-pressed paper) or a Rough surface to my paper, because I like the way it reacts to both wet colour and dry pencil and other drawing media; I tend to shy away from the smooth surface of hot-pressed (HP) paper. As a general rule, artists who paint with fine detail and very small brushes would be more inclined to work on an HP or vellum-surfaced paper. But I stress again: in painting there are no rules and experimentation with materials is the only way to find out what suits you best.

Drawing materials are many and varied. Dry media range from a simple graphite lead pencil to pastels (soft or oil), coloured pencils, carbon pencils, charcoal pencils, Conté crayons, compressed charcoal and so on – the list is almost endless. Wet media includes pens in all shapes and sizes: fibre-tipped pens, felt pens, art pens, fountain pens, dip pens and bamboo pens. All the aforementioned I have tried with watercolours, using them either for under-drawing or over-drawing. Again, if an idea suits a combination of materials, use them. Very often, the simplest combination is best and who is to say that a combination of several will not work – it's all about trial and error.

Outdoor equipment

When we speak of the perfection of art, we must recollect what the materials are with which a painter contends with nature. For the light of the sun he has but patent yellow and white lead – for the darkest shade, umber or soot.

John Constable (1776–1837)

I often wonder what the likes of Turner and Constable would produce nowadays with the plethora of materials and equipment on the market – the mind boggles!

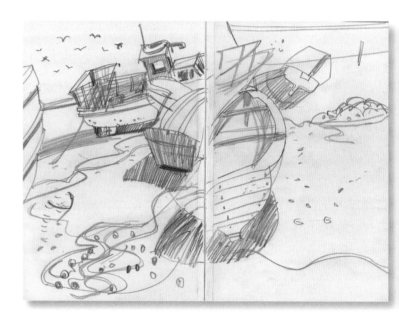

Left

This is the equipment that I take with me when painting outside *en plein air*. Everything fits neatly into my rucksack apart from the easel and folio.

Boatyard, Santa Luzia, Portugal

Cretacolor clutch pencil, 3B lead, Daler Rowney sketchbook 30 x 22 cm (12 x 8½ in.) Collection of the artist

A small compositional study made over two pages of this sketchbook. I enjoy letting a drawing wander across two pages, letting it go its own way. It's also a bit less inhibiting than trying to fit it into a pre-determined shape.

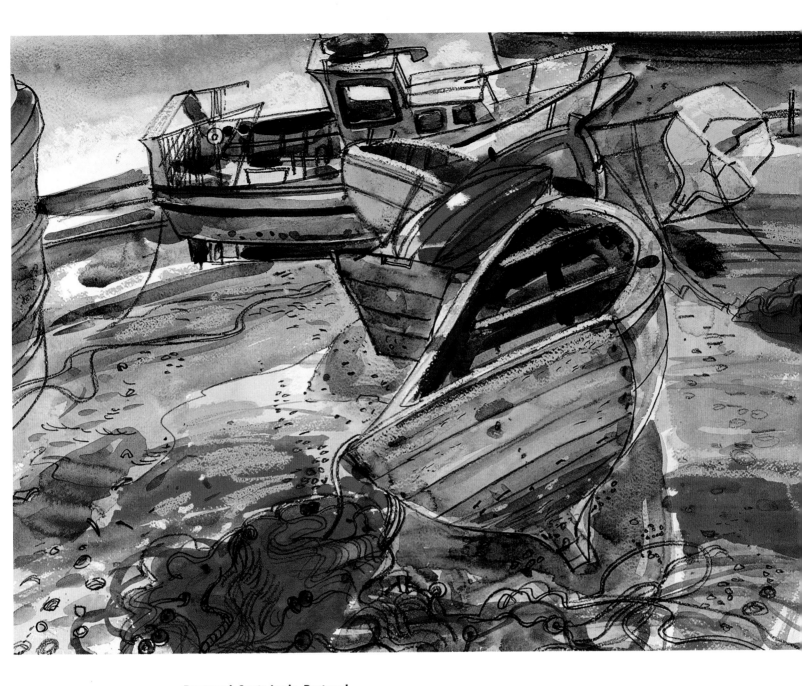

Boatyard, Santa Luzia, Portugal

Watercolour, Berol Karismacolor water-soluble pencil, oil pastels, Waterford NOT paper,
53 x 71 cm (21 x 28 in.) Private collection.

I liked the zig-zag line of boats leading my eye into the main boat in the background.
This was more like a graveyard for boats rather than a working boatyard; some of
the hulks looked as though they had been there for years and proved an irresistible
'draw' for me in more ways than one!

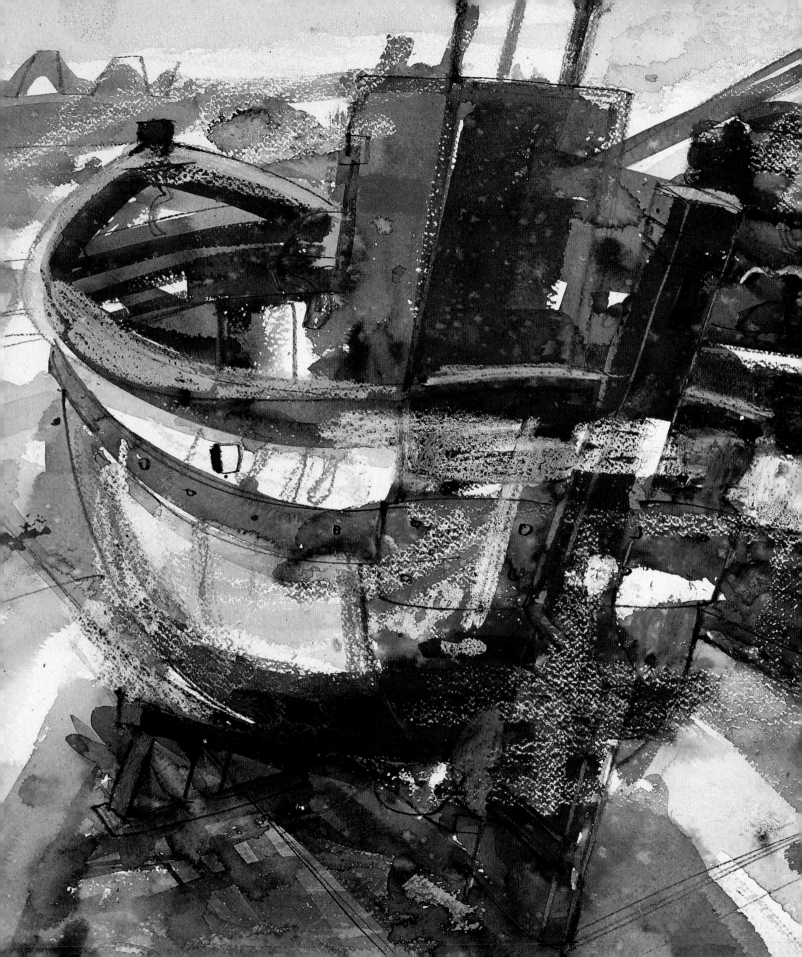

Discovering and exploring watercolour

With practice the craft will come almost of itself, in spite of you and all the more easily if you think of something besides technique.

Paul Gauguin (1848–1903)

When I start a painting, I don't begin by saying to myself that I'm going to use this method, or that technique, or whatever; I basically allow the method and materials I employ to be dictated by the idea or the thing I'm trying to paint. I have loved paint and the materials I use in making a painting ever since the age of eight, when my Uncle Adam gave me a birthday present of some brushes and a set of small tubes of oil paint, which he then proceeded to demonstrate how to use in a sketchbook.

Two Red Boats, Arniston, Western Cape, South Africa

Watercolour, Berol Karismacolor water-soluble pencil, oil pastels, Waterford 300 gsm NOT paper 53 x 71 cm (21 x 28 in.) Private collection

Wax resist and blotting were the two main methods I employed in this painting, where I was trying to get a feeling of the two heavily textured and weather-beaten boats resting on the slipway, covered in layers of peeling, rust-marked paint. I liked the abstract qualities of this painting, which only became apparent after I had finished it. I was initially tempted to work into it more, but resisted and decided to leave the background more or less empty, which made the boats look more monumental.

That moment has lived long in my memory and I can still recall the smell of linseed oil while watching transfixed as he magically conjured up a small portrait of me. I think that's when I first got the bug to paint.

Of course, painting with oils on paper was obviously not the best combination to use (my uncle just did it to get a small child interested in art – and succeeded), although some artists do use oil on paper. Choose the surface and materials you use to make a painting carefully, and use them to convey the idea, the scene, the effect of the light or whatever else you are trying to create; but above all else, enjoy experimenting with your chosen materials.

I am not a purist when it comes to painting in watercolours and I don't feel restricted to just using watercolour on its own. As long as any other materials employed work within the context of the painting, that's fine by me!

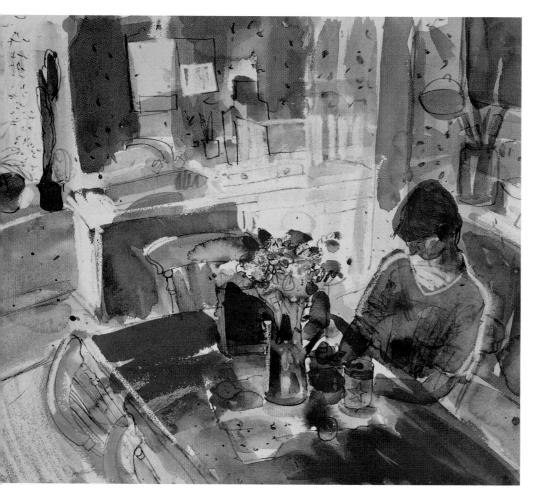

Kitchen Table, Little Hill Farm, Hurlford
Watercolour, Berol Karismacolor water-soluble pencil, oil pastels, Waterford 300 gsm NOT paper 53 x 71 cm (21 x 28 in.) Private collection
I regard myself as being extremely fortunate in that my 'job' as a painter has afforded me the fantastic opportunity to travel extensively around the world to observe, draw, record and think. I often laugh when I return from a painting trip and someone asks me: 'How was your holiday?' I have never seen myself as going on a holiday as such: it has always been a trip with the main purpose of painting and drawing... usually with an exhibition deadline looming. Even on our honeymoon, my wife Carol (also a practising artist) and I were drawing just about every day on the beautiful island of Crete.

Travelling to far corners of the Earth can be exciting and inspirational, yet quite often, stimulating subject matter can be found very close to home, as with this painting, made in the kitchen of a farmhouse we were renting while our house was being renovated.

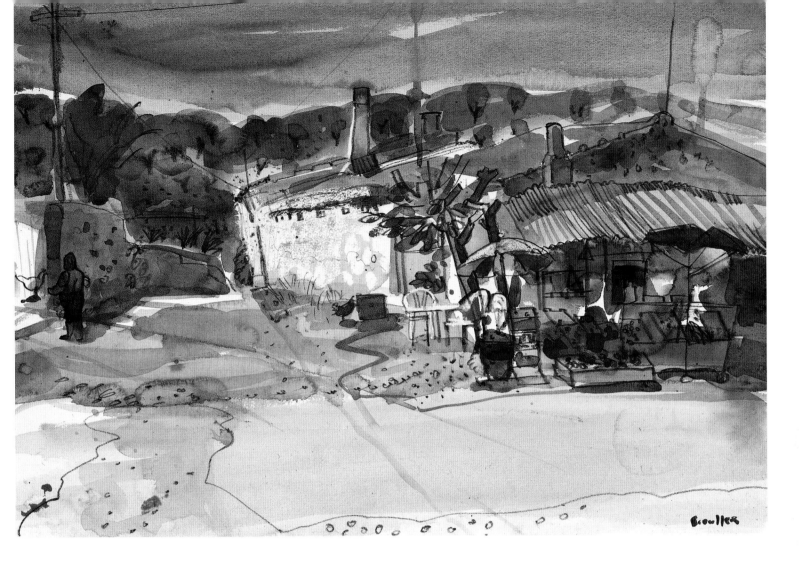

Mixed media

When it comes to working on paper, the range and scope of materials available for the artist is enormous. Manufacturers (or artists' colourmen) are continually bringing new products on to the market to encourage us to open our wallets. For me, the use of different materials in a single painting is a matter of trial and error, and the discovery of a successful combination of materials almost happens by accident. Being caught up in the fury and frenetic act of painting, you can easily grab the wrong thing in haste to apply to the wet paper – and it if it works in the context of the painting, I leave it.

Roadside Stall, Falacho, Algarve, Portugal
Watercolour, Berol Karismacolor water-soluble pencil, oil pastels, Waterford 300 gsm NOT paper 53 x 71 cm (21 x 28 in.) Private collection
Now and then, when I'm driving along a road in a foreign country, I wish I could just jam on the brakes and paint the wonderful scene that I am passing. Often, it isn't possible to do that. But to my delight, on this occasion I had a big, wide road in which to set up my easel and draw the arrangement in front of me, safe in the knowledge I wasn't going to be mown down by a speeding vehicle.

It is true that looking hard at a subject makes you grow as an artist. Endless days of trial and error hopefully makes you a little wiser each time you pick up a brush. Paintings can cross-fertilise each other, an idea in one can affect another. In the paintings throughout this book I have used various combinations of materials, some consciously planned as an experiment and others happening by chance.

I also try to be consciously aware of not using my materials in a gratuitous fashion.

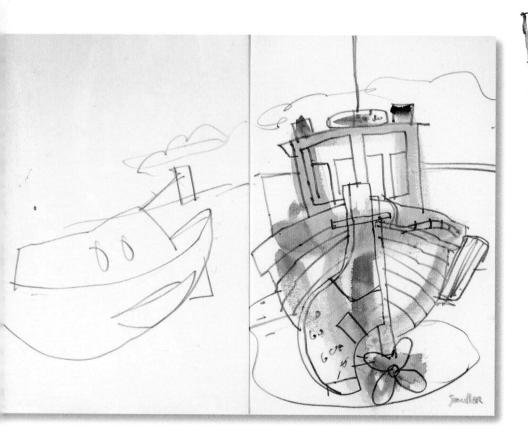

Boat, San Vincenzo, Italy

Watercolour, Berol Karismacolor water-soluble pencil, John Purcell watercolour sketchbook with NOT paper 42 x 30 cm (16½ x 12 in.) Collection of the artist
This is one of those very quick statements, made in front of a subject, which at the time had me in two minds about whether to continue with it or leave it alone. On this occasion I'm glad I left it, as I rather like the simplicity of it and the balance between the lines, shapes and the areas of colour.

Tabletop

Cretacolor clutch pencil with 6B lead, Roberson Bushey sketchbook Collection of the artist
Before setting up a big still life, I quite often do small sketches of different arrangements before deciding on the final composition. This was one such occasion where I did a number of drawings from different directions before I plumped for the final arrangement.

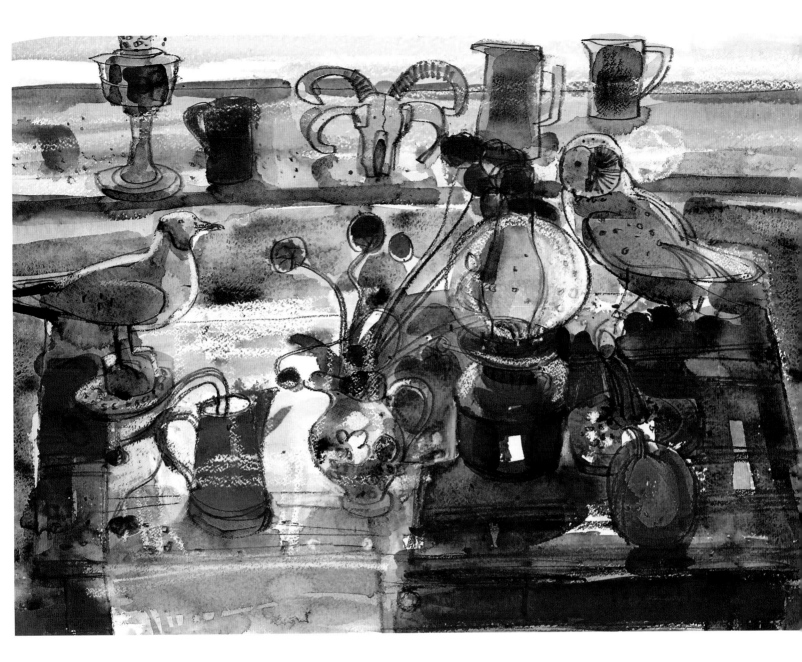

Nature Table with Owl

Watercolour, Berol Karismacolor water-soluble pencil, oil pastels, Waterford 300 gsm NOT paper 53 x 71 cm (21 x 28 in.) Private collection

This is a more controlled statement, where I arranged the objects in the still life before painting them. My preference is to 'find' or 'stumble upon' a still life, so I am constantly looking at the possibilities of everything around me. This, however, is not always possible and I occasionally have to invent an arrangement using objects that I have collected on my travels over the years.

Various items have provided backdrops, including tables, chairs and my studio floor. In this case it was a red-painted table and a window in the background. This particular table has been black, white, blue, yellow and green, as well as red. As the colour of the sky sets the mood in a landscape painting, the red of the table is the dominant colour here and sets the theme or mood of the painting.

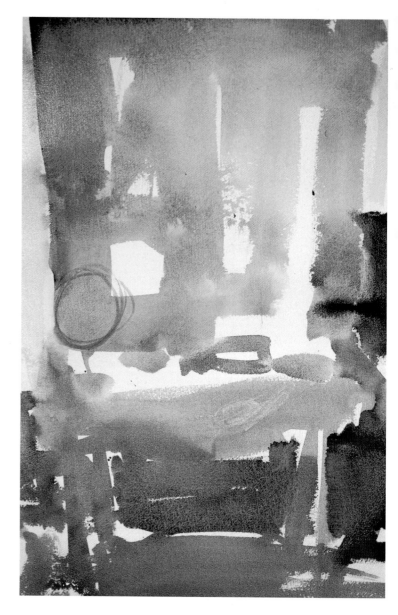

Demonstration: Still Life with Blue Background

Introduction

I decided to set up a portrait-shaped still life with three distinct areas. At the top there would be a large, quiet, empty background area and then a central part, which would be very busy with objects and colour. Finally, a lower foreground section with some sort of pattern or texture would lead your eye into the painting and prevent it from 'falling off' the bottom of the paper. For the success of the composition, it was important to have an area of quiet and calm to let the eye rest, in contrast to the busy tabletop and foreground; if it were busy all over, confusion would reign.

Materials

- White, green and pink oil pastels, Berol Karismacolor water-soluble pencil.
- Watercolours: alizarin crimson, Winsor red, cadmium yellow, Payne's grey, ultramarine blue.
- Brushes: numbers 10 and 12 squirrel mops (Rosemary & Co.), numbers 12 and 16 Kolinsky sables (Escoda, Optima range).
- Saunders Waterford 300 gsm NOT paper, 33 x 53 cm (13½ x 21 in.).

Stage 1

I started off by using a white oil pastel to pinpoint the rough placing of the two lightest objects in the still life – in this case it was the dove and circular lantern reflector. This process has a dual purpose – it preserves the areas as light tones while at the same time creating an area of textural interest. I then began to block in the main areas of the composition in the three primary colours, using flat washes with plenty of water and not too much pigment. I wasn't too concerned, at this stage, if the colours ran into each other, as accidental effects can be quite exciting if they work within the context of a painting.

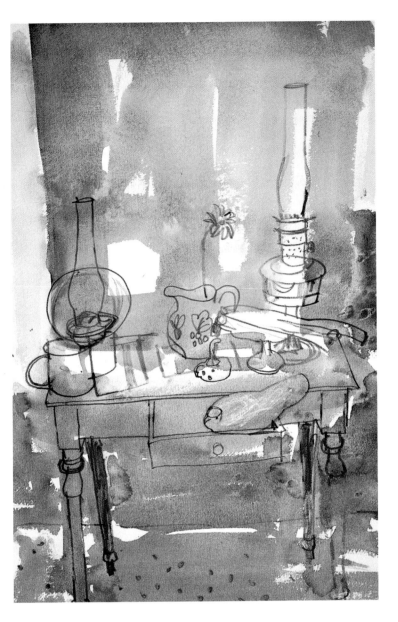

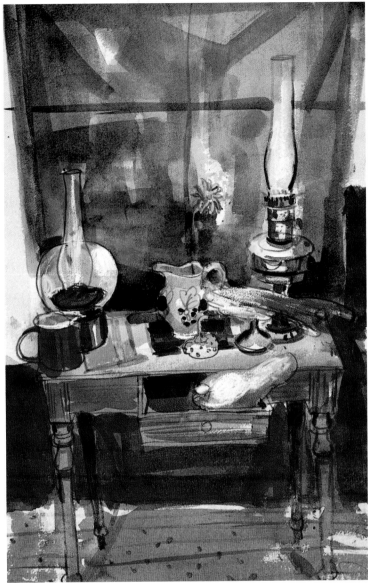

Stage 2

I then drew into the washes with a water-soluble pencil. It is important to work rapidly at this stage, while the first wash is still wet, as the pencil marks will become 'absorbed' into the painting and form a homogenous part of it. If the wash is dry, the pencil will leave an irritating shiny surface that catches the light and the eye – so speed is essential!

Stage 3

Using the largest brush – loaded with pigment but still keeping the washes very puddled – I strengthened the background areas with more saturated colour. Then, progressively working with smaller brushes, I began working into the objects on the table by creating shadows with darker, more controlled washes, paying attention to the dark values. I used mixes of alizarin crimson, French ultramarine and a touch of Payne's grey to create form in the objects and the shadows on the table, and to correct any drawing mistakes. Finally, I used a bright pink oil pastel on the cloth, together with judicious use of the white oil pastel where required.

Demonstration:
Self-Portrait with Still Life

Introduction

This painting was a bit of an experiment, as I had recently acquired some Lascaux watercolours, which come in small plastic bottles with the colours inside resembling very runny cream. Let me say, first of all, that I don't think these are for the purist watercolour artist. They have a slightly greasy feel to them and if applied without enough water, they leave a pronounced brushmark. Having said that, I rather liked them, especially their intensity of colour. Plus, if you are covering a large area, it's easy to mix large quantities of colour. You also need to be aware that a palette with deep wells may be required, because they will run into each other if not separated by some means.

Materials

- Berol Karismacolor water-soluble pencil.
- Watercolours: permanent red, permanent yellow, ultramarine blue, lemon yellow, anthracite black (Lascaux Aquacryl artists' watercolours).
- Brushes: large mop, numbers 12 and 16 Kolinsky sables (Escoda, Optima range).
- Saunders Waterford 300 gsm NOT paper, 71 x 53 cm (28 x 21 in.).

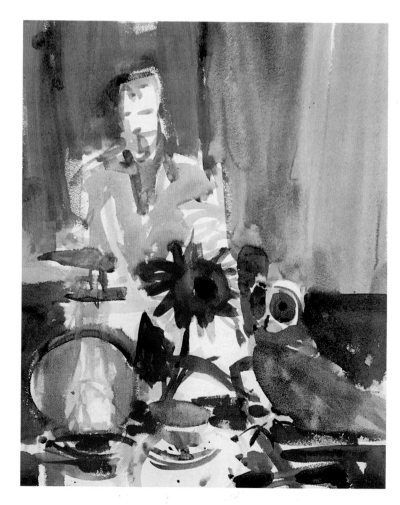

Stage 1

I started this painting by roughly sketching in the basic big shapes with the no. 16 sable loaded with ultramarine blue. Then, using the large mop, I covered the background with the same colour. Blue is a good colour to use for drawing a basic composition as it is easy to 'lose' it in a painting.

Stage 2

I then introduced some thin colour washes into the main foreground objects.

Stage 3

Finally, I drew into the whole painting with the water-soluble pencil and quickly added stronger, more intense washes throughout while keeping the blue as a strong element in the painting. With the no. 12 brush, I worked fine lines into the patterned jug, owl and lantern.

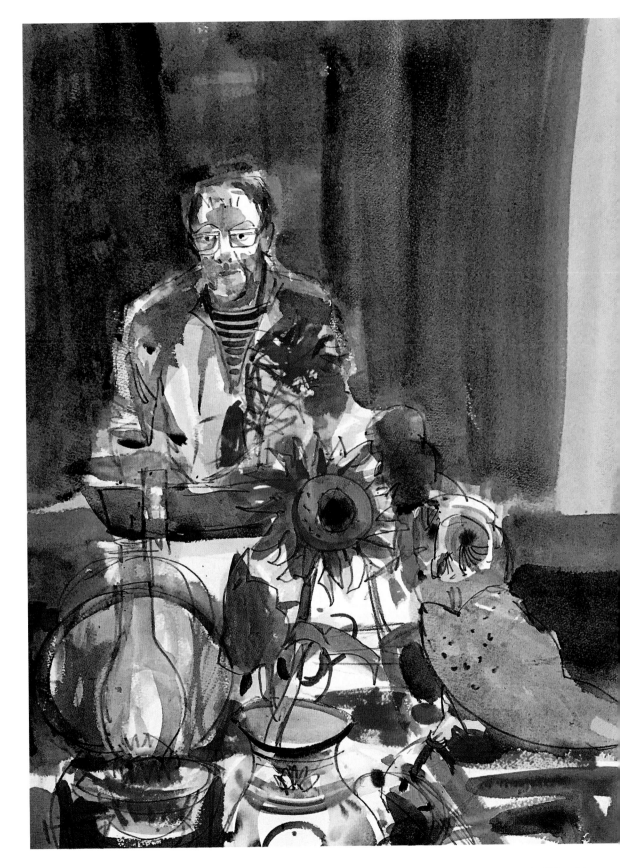

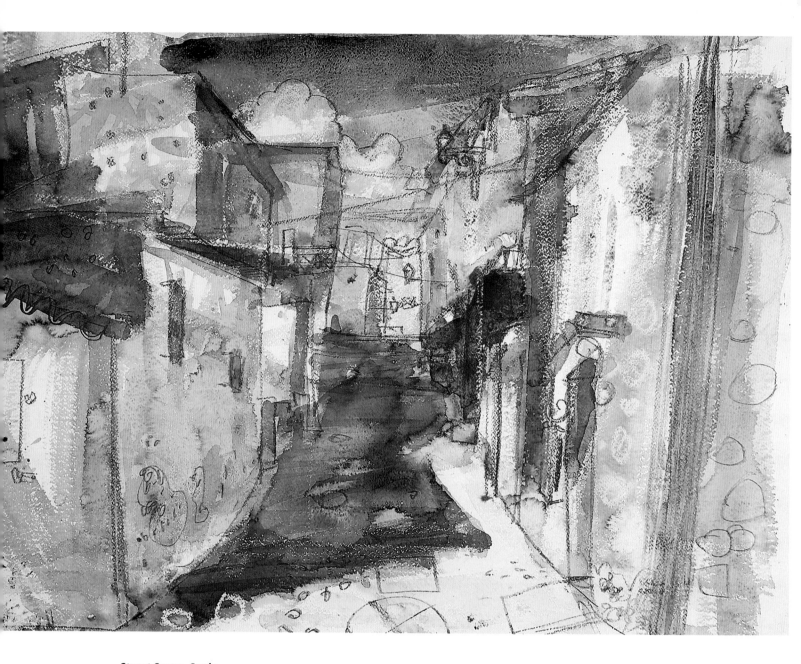

Street Scene, Spain

Watercolour, Berol Karismacolor water-soluble pencil, oil
pastels, Fabriano Artistico 300 gsm Rough paper
53 x 71 cm (21 x 28 in.) Private collection

Sunlit textured walls are always a favourite theme of mine
and the rough surface of the Fabriano paper was ideally
suited for this subject. I used a white oil pastel to indicate
the placing of some of the white walls, then quickly covered
the whole sheet with pale washes to kill the glaring white

of the paper, at the same time trying to preserve areas that
had the lightest values in the scene. Then it was time to
strengthen the depth of the colour with a heavily loaded
brush intensely fortified with rich pigment, again trying to
preserve certain areas of white. And, as with the previous
stages, I worked at breakneck speed while the painting was
still wet, drawing into it to give definition, clarity and texture
and to expose certain architectural details.

Farmer and Moped, France

Watercolour, Berol Karismacolor water-soluble pencil, John Purcell watercolour sketchbook with NOT paper 42 x 30 cm (16½ x 12 in.) Collection of the artist

This is one of those drawings that are created by happenstance. I was in the middle of doing a large landscape when out of the corner of my eye, I spotted a farmer pushing his moped along the road behind me. Finding him to be a more exciting subject than the landscape, I quickly dropped what I was doing, did a 180° turn, grabbed my sketchbook and rapidly blocked him in. Simplicity was key: there was no time for too many details and I tried hard to memorize what I had just seen.

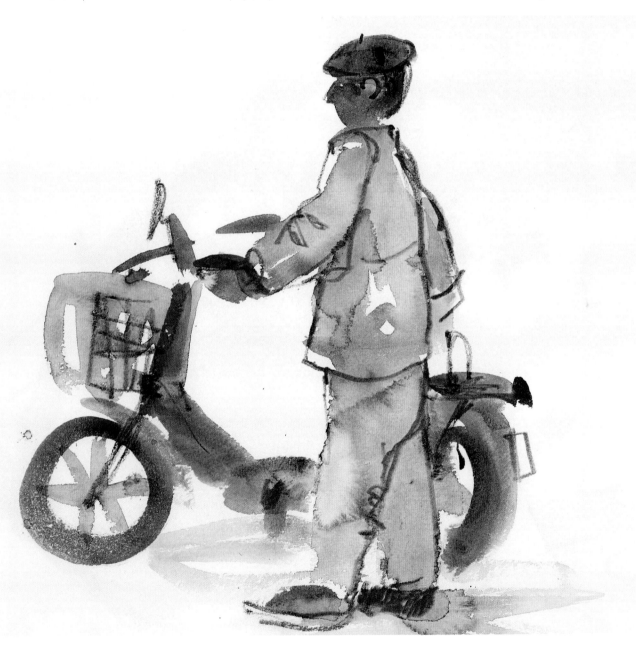

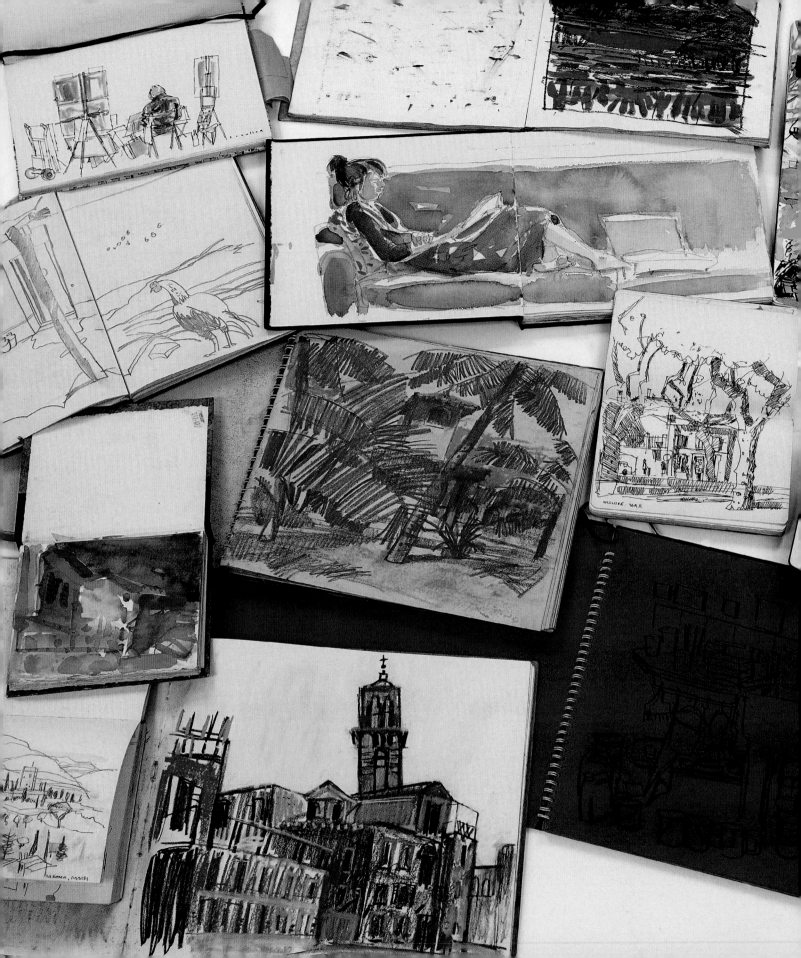

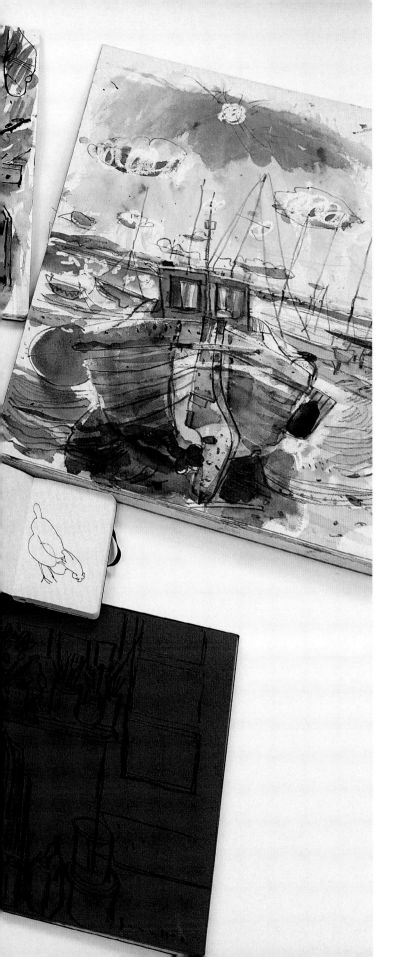

Book and paper choice

A fine suggestion, a sketch with great feeling, can be as expressive as the most finished product.

Eugène Delacroix (1798–1863)

Sketchbooks come in many guises, shapes and sizes. Some artists make them up themselves using their favourite papers, and others have them specially made to order by professional bookbinders. I have gone down both of those routes myself in the past. But nowadays there are so many different shapes and sizes on the market to choose from, in a broad range of papers (including different types of watercolour paper), that the artist is almost spoiled for choice.

When I am in a foreign city I try to visit the local art shops to find out what's on offer and perhaps unavailable in the UK. Italy, for example, is a wonderful place to buy sketchbooks, especially Florence and Venice. Both cities are full of small, artisan bookbinding shops where you can buy beautiful leather-bound books at a reasonable price. These are a joy to use once you get over the initial fear of making marks in them.

Selection of sketchbooks

A selection of sketchbooks, some of which are manufactured specifically for watercolours, negating the need to stretch paper. As you can see, they come in all shapes and sizes. Some are stitched with glued covers, others are spiral-bound, and some come glued at the edges as a block.

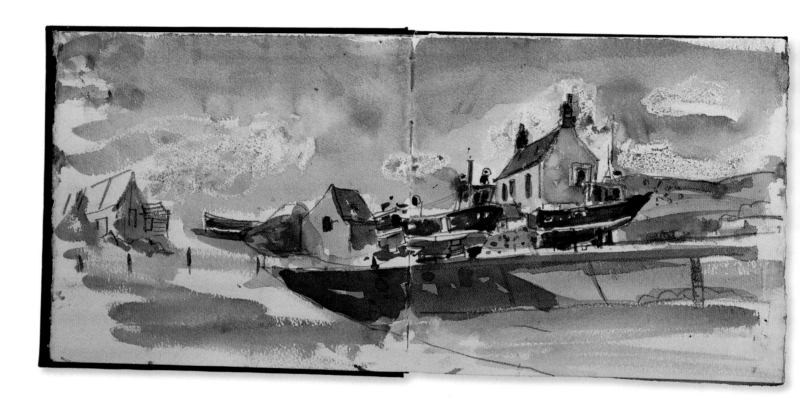

St Abbs

Watercolour, 6B pencil, Saunders Waterford sketchbook with 300 gsm NOT paper 26 x 29½ cm (10 x 11½ in.) Collection of the artist
This is one of a series of drawings I made of St Abbs in this sketchbook. I like the square format, which I quite often extend to a landscape shape, with the drawing going across two pages.

When I was a student I didn't feel the need for a sketchbook, using single sheets of paper for life drawing or doing studies out of doors. Even when I was awarded a travelling scholarship to Crete, I took a portfolio full of single sheets of paper and it wasn't until a few years after leaving art school that I got into the habit of using sketchbooks. This probably coincided with my urge to travel more and seek out new and exciting images to draw and paint, and perhaps to also try to increase my visual vocabulary. Nowadays, a sketchbook is a much more important item for me than a camera. Photographs, more often than not, contain too much information, whereas a drawing or sketch is the result of a process in which you have edited the important elements in front of you and put them down in a concise way, either as an exercise to keep the hand and eye connection in working order, or alternatively to use as source material for future work in the studio.

Which is best for me?

If the sketchbook is for drawing purposes only, I would choose one with a smooth surface, such as the Daler-Rowney perforated book, which is excellent for pencil and pen work. I also enjoy the Moleskine (pronounced 'Mole-eh-skiney') books, which in recent years have been given almost cult status on the Internet.

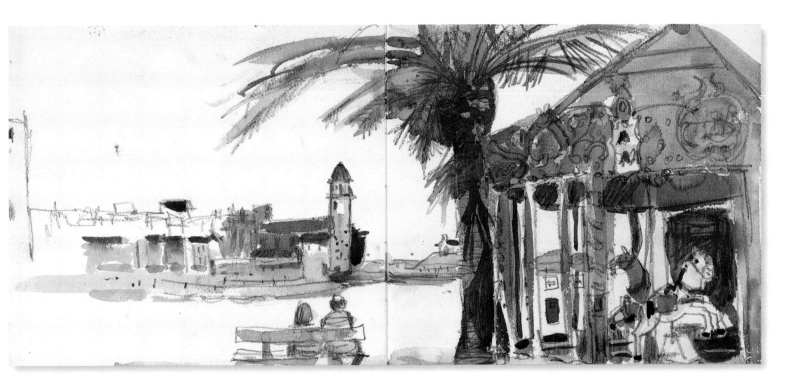

Carousel, Collioure, France

Watercolour, 6B pencil, Saunders Waterford sketchbook with 300 gsm NOT paper 26 x 29½ cm (10 x 11½ in.) Collection of the artist

The famous church in the background, L'Église Notre Dame des Anges, is situated at the edge of the sea on a rocky outcrop in the town of Collioure and must have been painted a million times by artists over the centuries. Its rather phallic-shaped tower is synonymous with the town and its religious and cultural heritage. In this drawing, I thought I'd put a different slant on a well-documented image and include the carousel and palm tree in my composition. The couple in the foreground sat on the bench when I had almost finished working, so I quickly put them in, but I now regret positioning them directly under the church tower. I think the picture would have had a better balance if they were more to the left of the composition. Done instinctively in haste!

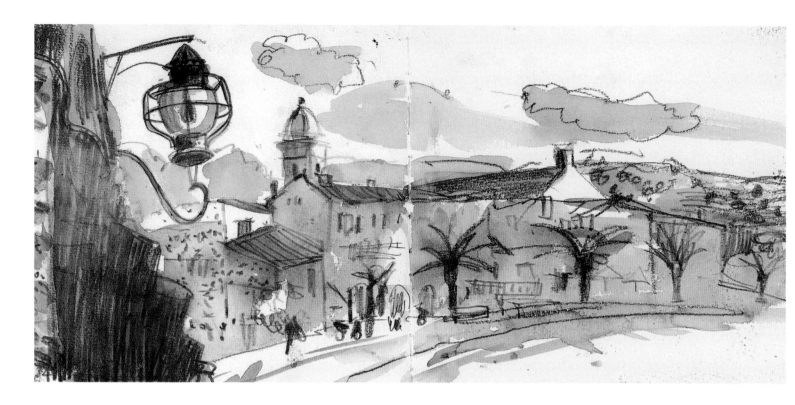

With regard to watercolours, if you have an eye for detail and enjoy working with fine pens or a harder grade of pencil, then probably a smooth HP (hot-pressed) paper is best suited to your needs. If you prefer a more painterly approach, then a NOT (cold-pressed) or Rough surface is likely to be more suitable. The hardbound Saunders Waterford watercolour sketchbooks are available with three different paper surfaces and in an almost square format. Alternatively, I also like the John Purcell range of sketchbooks, which also come with Saunders Waterford paper in three paper types, but in a larger landscape format.

Throughout this book I have tried to detail the different sketchbooks, papers and materials I have used in each work; hopefully this might prove an interesting starting point for the reader.

Lantern, Collioure, France

Watercolour, 6B pencil, Saunders Waterford sketchbook with 300 gsm NOT paper 26 x 29½ cm (10 x 11½ in.) Collection of the artist

For several centuries, the small Catalan port of Collioure has been a favourite haunt of artists, including Picasso, Braque, Dufy, Derain, Matisse and the Fauves. The attraction of this destination becomes apparent when you see the great variety of subject matter on offer, including Catalan fishing boats (sadly there are not as many as in Matisse's day), bathers, beaches, markets, colourful buildings and a wonderful terraced hinterland covered in vineyards. It is also a great place to be based, with many attractive hilltop villages within an easy 30-minute drive. This drawing was made beside the École de Plongée, looking towards the Plage Boutigue; again it is a common view but given an added twist by including the lantern in the foreground, creating a sense of scale and distance in the sketch. I used only four colours for this quick study: Payne's grey, cadmium yellow, alizarin crimson and yellow ochre. It was more of a tonal exercise than a statement about colour.

Kim Reading, Collioure, France

Watercolour, 6B pencil, Saunders Waterford sketchbook with 300 gsm NOT paper 26 x 29½ cm (10 x 11½ in.) Collection of the artist

My daughter Kim sat still for half an hour while I did this drawing of her sitting on our friend Felicity's wonderful pink couch. Depending on the light and time of day, the colour of the couch goes from pink to mauve and many shades in between.

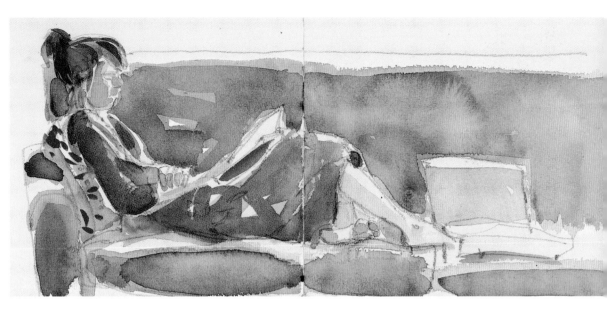

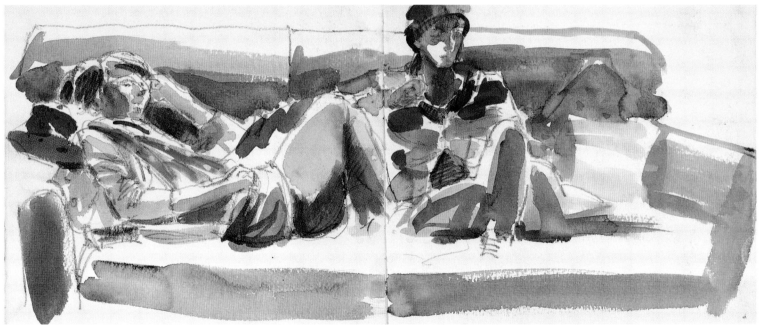

Kim and Lara Relaxing, Collioure, France

Watercolour, 6B pencil, Saunders Waterford sketchbook with 300 gsm NOT paper 26 x 29½ cm (10 x 11½ in.) Collection of the artist

My two daughters have made great models since they were young babies. As they grew older and a bit more savvy, they would have to be bribed to sit still. Nowadays they are in their thirties, have flown the nest and are both fine artists in their own right, but I seize the opportunity to paint them whenever I can.

Narrow Alleyway, Umbria, Italy

Watercolour, Berol Karismacolor water-soluble pencil, John Purcell watercolour sketchbook with 300 gsm NOT paper 42 x 30 cm (16½ x 12 in.) Collection of the artist

These four drawings were done during a very hot, sunny afternoon in a small, quiet Umbrian hill town. My idea was to record how a scene changed – including shadows, colour etc. – with the movement of the sun. During the course of the day I only moved slightly, as I recall, to stop myself frying in the ferocious Italian sun! The drawings were all made with a limited palette of two or three colours plus over-drawing with a very soft water-soluble pencil. John Purcell watercolour books are terrific and come in the usual HP, NOT or Rough paper in weights of either 300 gsm or 190 gsm. I use the 300 gsm as it can take a fair bit of battering without showing signs of furrows and ridges, plus the sketchbooks have very thick, sturdy cover boards and the papers are stitched together.

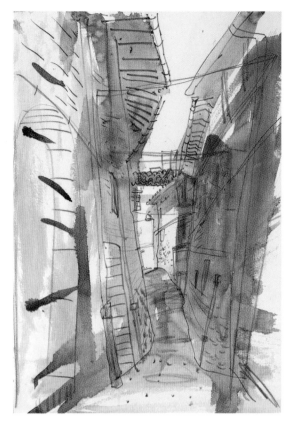

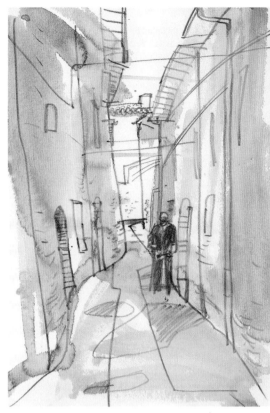

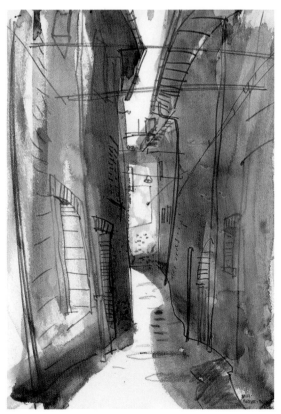

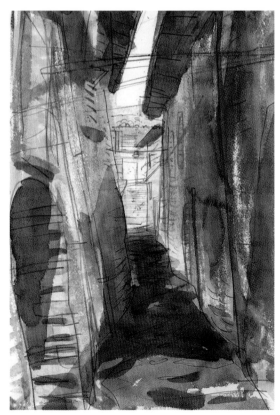

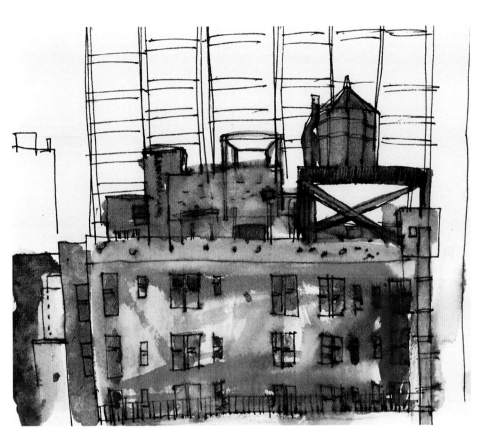

New York Buildings, USA

Watercolour, fibre-tip pen, sketchbook bought in New York
19 x 21 cm (7½ x 8 in.) Collection of the artist
Drawn from my hotel window at the rear of the hotel, this is
not the best of views, but an interesting scene nevertheless,
with the water towers on the roof of the building creating
an unusual New York skyline.

Trees, Liberty Island, New York, USA

Fibre-tip pen, sketchbook bought in New York
19 x 21 cm (7½ x 8 in.) Collection of the artist
I made a trip to see the Statue of Liberty and
was overwhelmed by the size of it. I made this
quick sketch of it through the trees, where it
looked quite small in the distance in relation
to the nearby trees. This was just a different
viewpoint on a familiar landmark and American
national treasure.

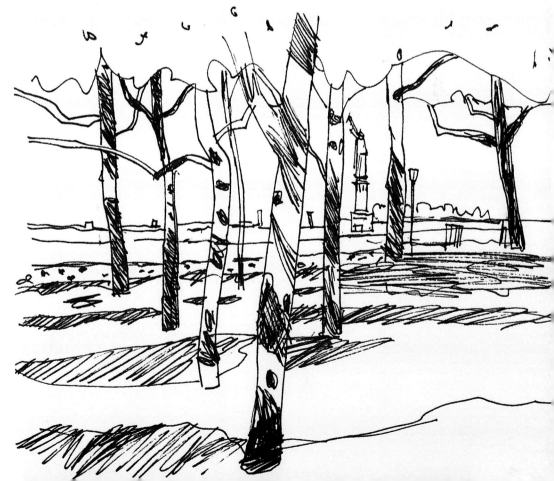

Street Artists, Uffizi Palace, Florence, Italy

Fibre-tip pen, sketchbook bought in Florence 21 x 30 cm (8½ x 12 in.) Collection of the artist

These four doodles were made in a sketchbook that I bought on one of the trips to Florence my wife and I have made over the years in the company of two very good friends. It is a magical place to visit, with so many interesting things to draw. The book came from one of the many artisan bookbinding shops in the city. This particular sketchbook attracted me because of the lovely colour and smooth surface of the paper – I could see that it would be ideal for pencil or ink and would also accept light washes of colour, as can be seen here.

The subjects are some of the many street artists who abound in the city, each trying to earn a living by selling paintings of the city or doing quick drawings or caricatures of tourists. These particular artists were situated in a small square outside the Uffizi Palace. I had to hide behind a pillar while drawing them, as they didn't like being photographed or drawn by anyone – perhaps they were concerned about attracting the attention of the tax authorities!

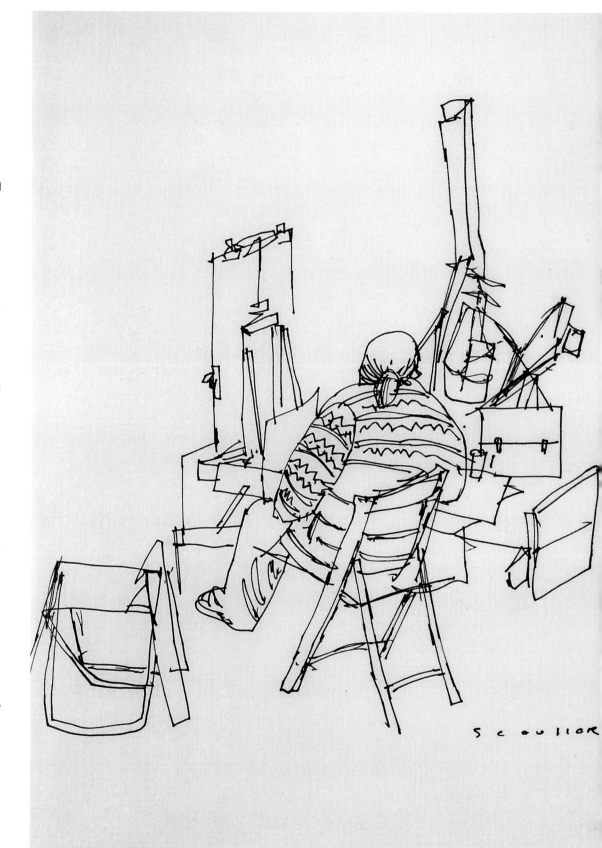

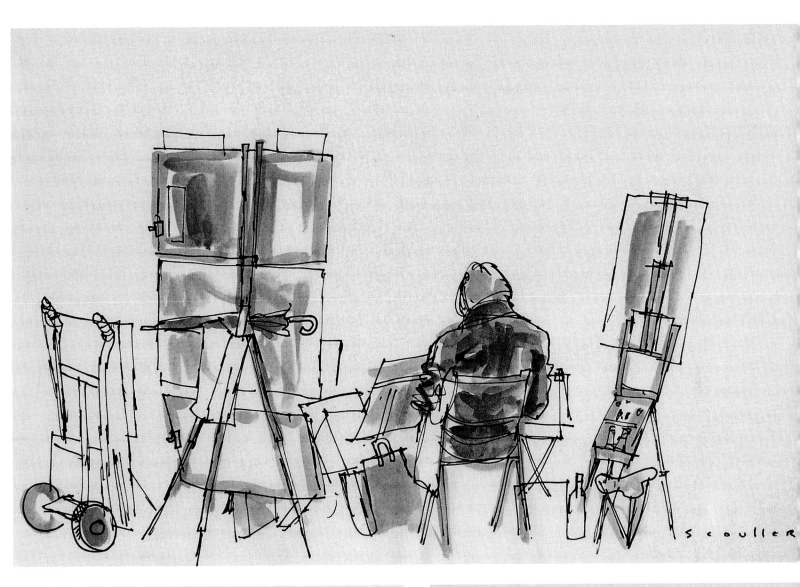

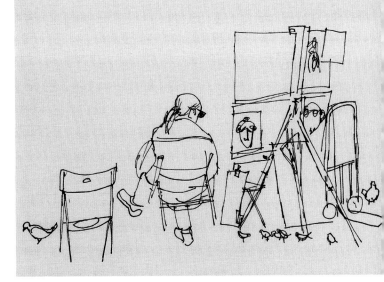

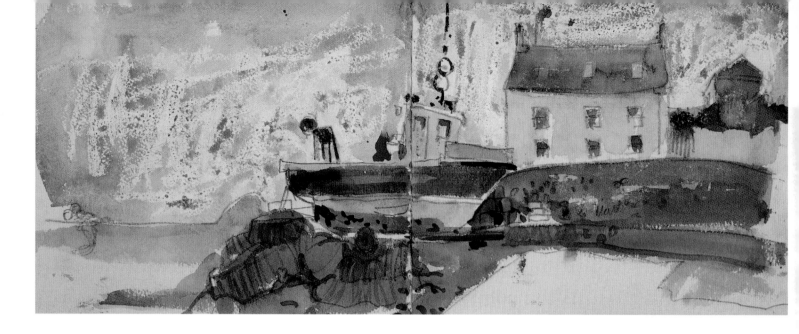

Boat and House, St Abbs

Watercolour, 6B pencil, oil pastels, Saunders Waterford sketchbook with NOT paper 26 x 29½ cm (10 x 11½ in.) Collection of the artist

I discovered the small Northumberland fishing village of St Abbs and was immediately impressed by its workmanlike atmosphere, visual possibilities and friendly fishermen. It was early spring and obviously the time of year when maintenance work is carried out on the boats out of the water. The possibility of figures at work on the boats made it much more interesting for me to draw. The blue sky in these drawings belies how cold it was, but fortunately I was well prepared. It seems an obvious thing to say, but it is vital to check the weather forecast before setting off on an outdoor painting trip. An old adage that immediately springs to mind is also true: 'There is no such thing as bad weather – only bad clothing!'

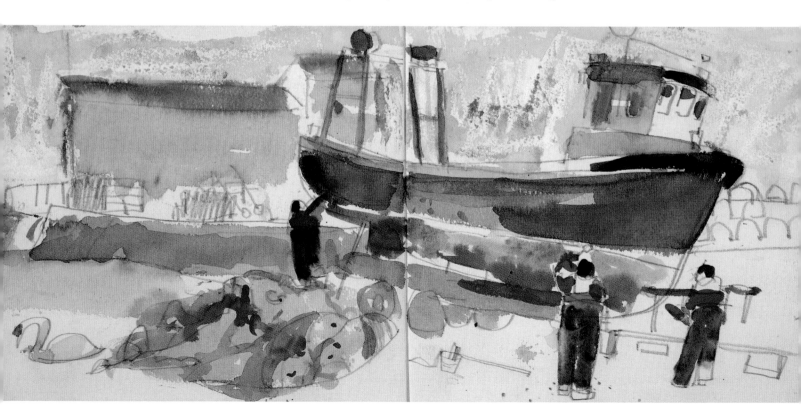

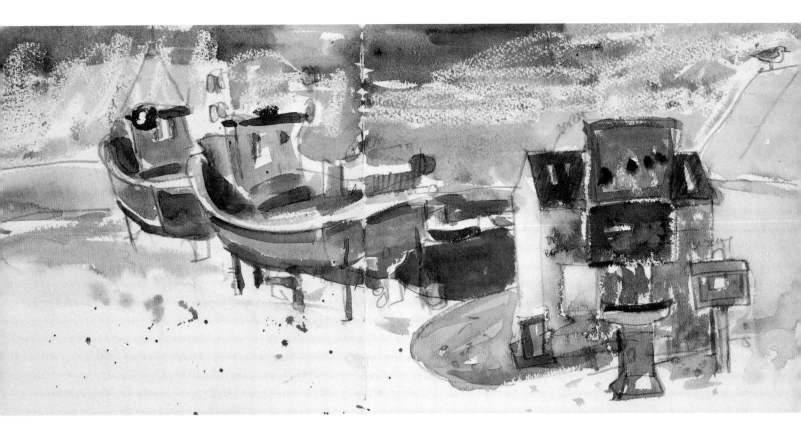

The Swan, St Abbs

Watercolour, 6B pencil, oil pastels, Saunders Waterford sketchbook with 300 gsm NOT paper 26 x 29½ cm (10 x 11½ in.) Collection of the artist

This was interesting because of the figure – and I do mean 'figure' in the singular. The fisherman in the colourful oilskins kept working his way around the boat, so I quickly drew him in the different positions he took up while painting or spraying his boat. I also liked the swan (bottom left) that seemed to have taken up permanent residence in the harbour. Back in the studio, I later worked up a large oil painting based on this drawing.

Boats and Sheds on the Quay, St Abbs

Watercolour, 6B pencil, oil pastels, Saunders Waterford sketchbook with 300 gsm NOT paper 26 x 29½ cm (10 x 11½ in.) Collection of the artist

I made this drawing from inside the car, just before leaving St Abbs, and added the colour back in my studio from notes I made *in situ*.

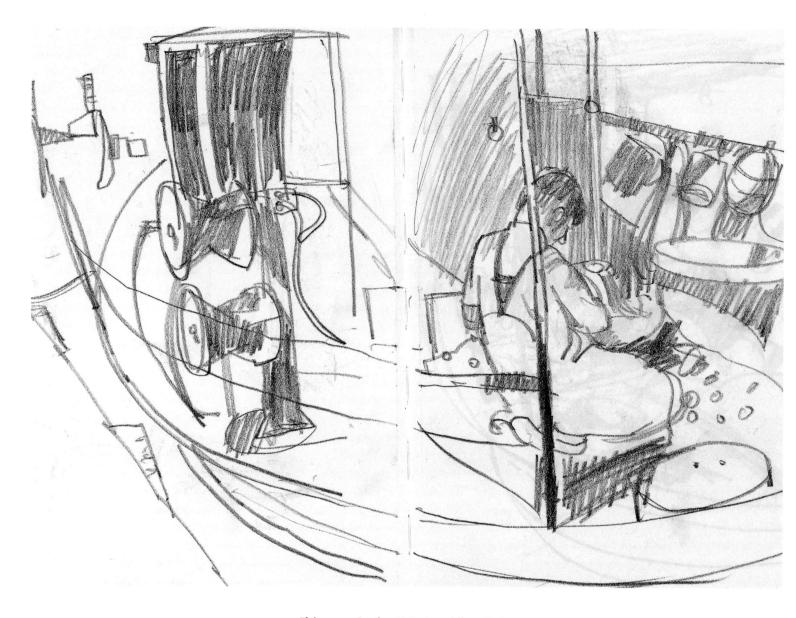

Fisherman Sorting Nets, Heraklion, Crete

Staedtler clutch pencil, 4B lead, Daler Rowney sketchbook 30 x 22 cm (12 x 8½ in.)
Collection of the artist

This drawing was made in my favourite sketchbook for pencil work, the Daler-Rowney perforated-page sketchbook. I love the ivory-coloured, smooth-textured paper, which is great for use with soft pencil or pen and ink. It is probably the type of sketchbook I have been using the longest: I have some that go back 30 years or more. Crete is very special to me: I spent three months there on a scholarship from art school, had my honeymoon there, and have been back to paint on several more occasions. In this quick drawing I liked the arrangement of shapes and shadows of the objects on the boat created by the gruelling Cretan sun; amidst this the fisherman goes about his business mending the nets.

Café People, Cadaqués, Spain

Watercolour, 6B pencil, Saunders Waterford sketchbook with 300 gsm NOT paper 26 x 29½ cm (10 x 11½ in.) Collection of the artist

This was drawn while sipping a well-deserved ice-cool beer after a gruelling two-hour drive down a twisting, treacherous coastal road from Collioure in France to Cadaqués in Spain.

The journey was well worth it: the beautiful old town of Cadaqués has a maze of narrow streets, dazzling white seafront buildings in stark sunlight and shadow, and many small boats. I was so taken with it that we made the trip again the following week. It's definitely a place where I would like to spend more time painting.

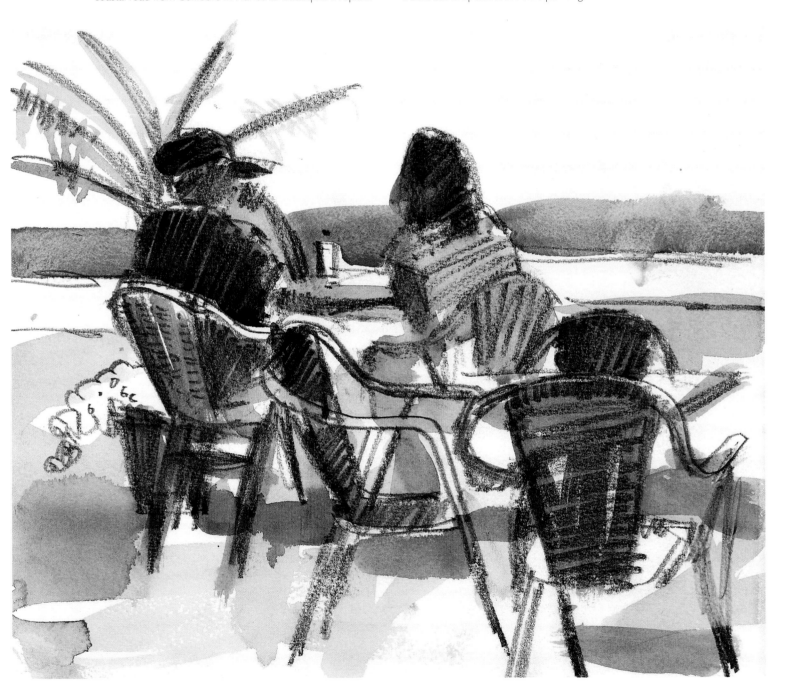

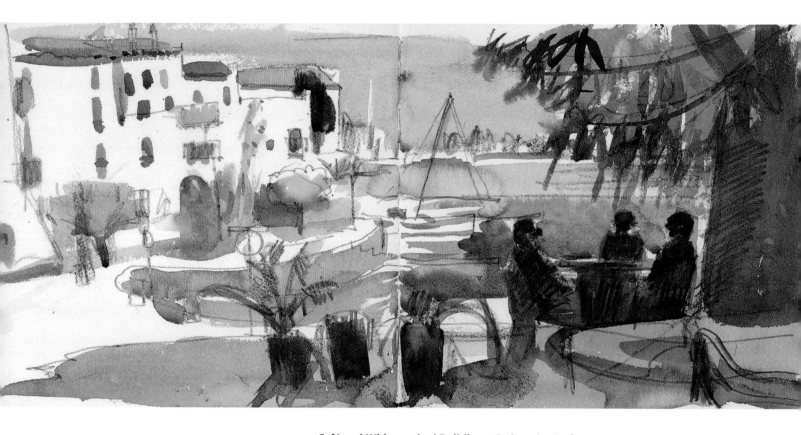

Café and Whitewashed Buildings, Cadaqués, Spain

Watercolour, 6B pencil, Saunders Waterford sketchbook with 300 gsm NOT paper
26 x 29½ cm (10 x 11½ in.) Collection of the artist

Another day, another trip and another beer in the same café! This time there
was a different clientele to draw and the vista was different. I included a
bit of background in this colour study. I liked the contrast of the shadowed
foreground, with the dark figures silhouetted against dazzling white buildings
and a blue sea. In situations like this, it's important to get the mid-values right
and see that there really is colour in the shadows. All too often, I see paintings
in galleries where the 'artist' has obviously worked from a photograph and not
really observed what's going on in the shadow areas.

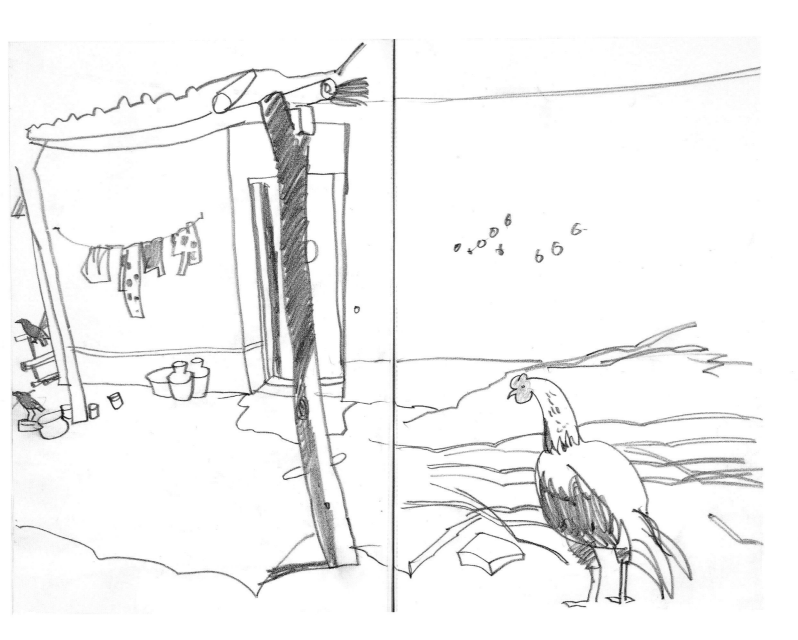

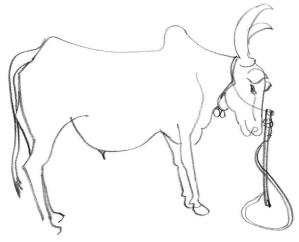

Sacred Bull, Bangalore, India

Cretacolor clutch pencil with 6B lead,
Daler-Rowney sketchbook 30 x 22 cm
(12 x 8½ in.) Collection of the artist
Cattle are held in high regard and are
sacred animals within Indian religions.
This one was a very obliging model as
it was tethered to a post; normally the
animals roam the streets and everyone
moves aside for them to pass.

Street Scene, Huskur, Bangalore, India

Cretacolor clutch pencil with 6B lead,
Daler-Rowney sketchbook 30 x 22 cm
(12 x 8½ in.) Collection of the artist
A typical village scene, rich with subject
matter for drawing. I love the way that the
people let their animals roam wild in the
streets, including cows and bulls.

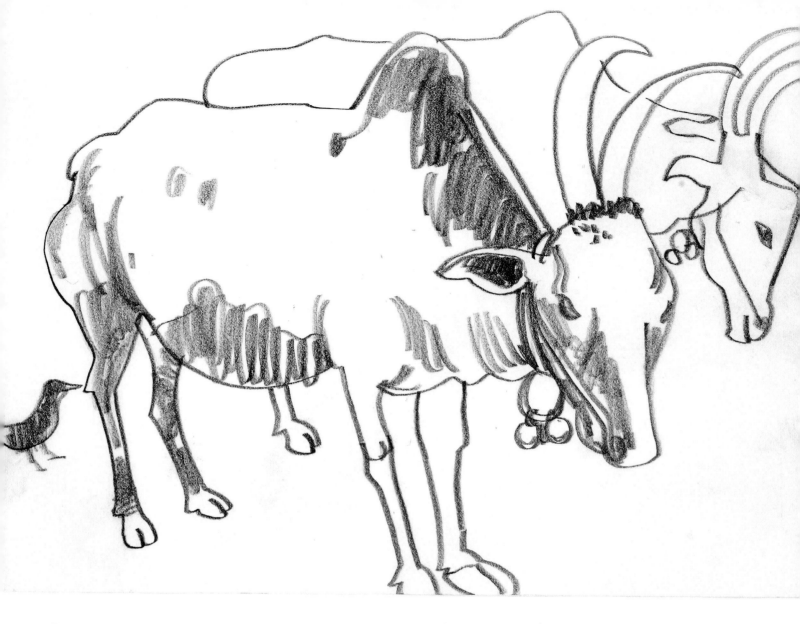

Bulls and Blackbird, Bangalore, India

Cretacolor clutch pencil with 6B lead, Daler-Rowney sketchbook
30 x 22 cm (12 x 8½ in.) Collection of the artist
In this drawing, I liked the blackbird pecking at the bull's leg,
as it gave the whole thing a sense of scale.

Preparing Tamarind Paste, India

Cretacolor clutch pencil with 6B lead, Daler-Rowney sketchbook
30 x 22 cm (12 x 8½ in.) Collection of the artist
I enjoy drawing people at work and India is particularly good for
this subject, as it's a nation full of people doing things by hand. In
the West we would probably have a machine to do this man's job.

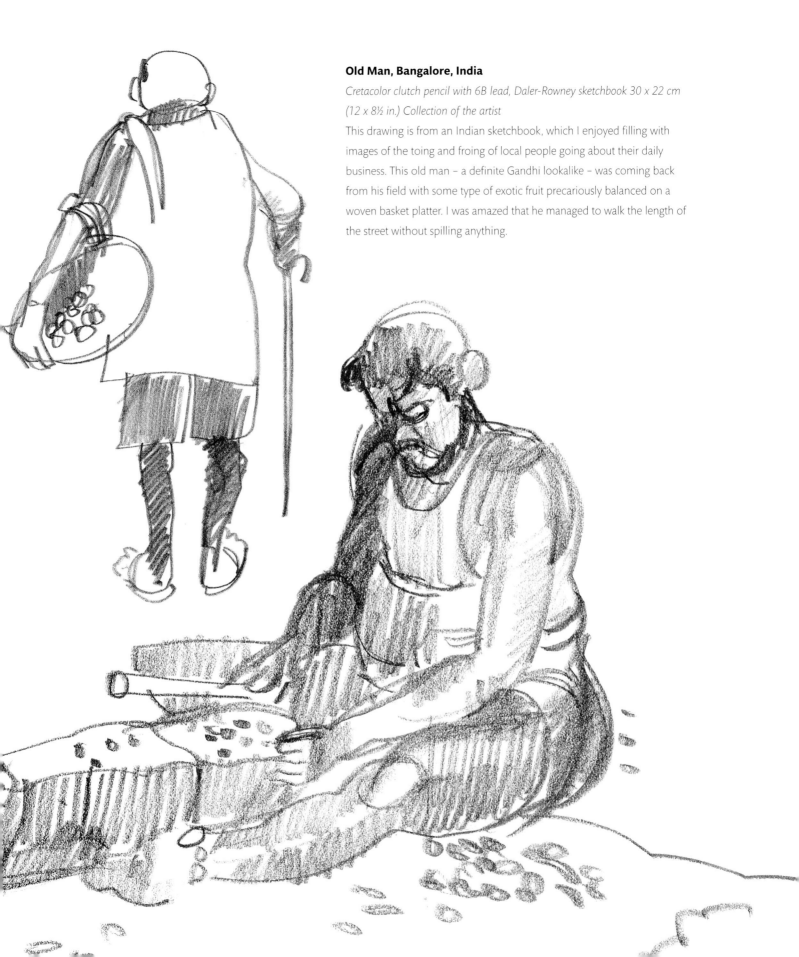

Old Man, Bangalore, India

*Cretacolor clutch pencil with 6B lead, Daler-Rowney sketchbook 30 x 22 cm
(12 x 8½ in.) Collection of the artist*

This drawing is from an Indian sketchbook, which I enjoyed filling with
images of the toing and froing of local people going about their daily
business. This old man – a definite Gandhi lookalike – was coming back
from his field with some type of exotic fruit precariously balanced on a
woven basket platter. I was amazed that he managed to walk the length of
the street without spilling anything.

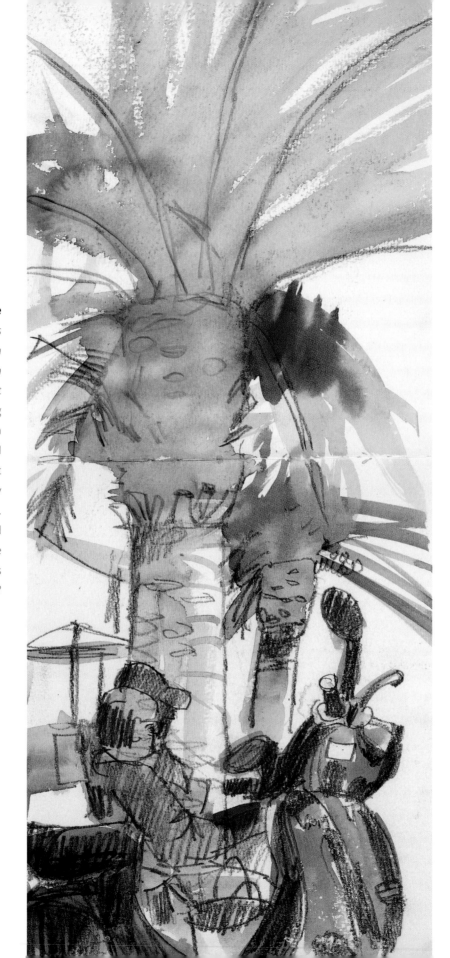

Moped, Collioure, France

Watercolour, 6B pencil, Saunders Waterford sketchbook with 300 gsm NOT paper 26 x 29½ cm (10 x 11½ in.) Collection of the artist
As I was drawing this couple having a coffee under a shady palm on the seafront in Collioure, a local suddenly parked his moped right in front of me. He was completely oblivious to what I was doing. Rather than abandon all, I included it in my drawing. It was not the composition I planned, but perhaps better – who knows?

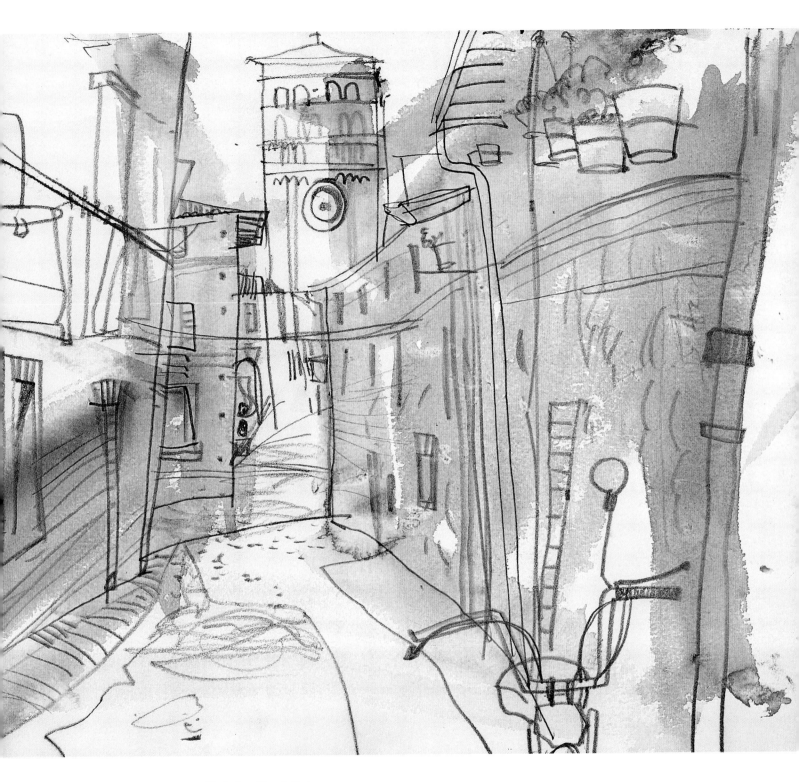

Umbrian Street, Italy

Watercolour, Berol Karismacolor water-soluble pencil, John Purcell watercolour sketchbook with NOT paper 42 x 30 cm (16½ x 12 in.) Collection of the artist

This quick drawing, done with just a wash of yellow ochre and drawn over with a pencil, reminded me of a Ben Nicholson – a very sketchy, loose Ben Nicholson!

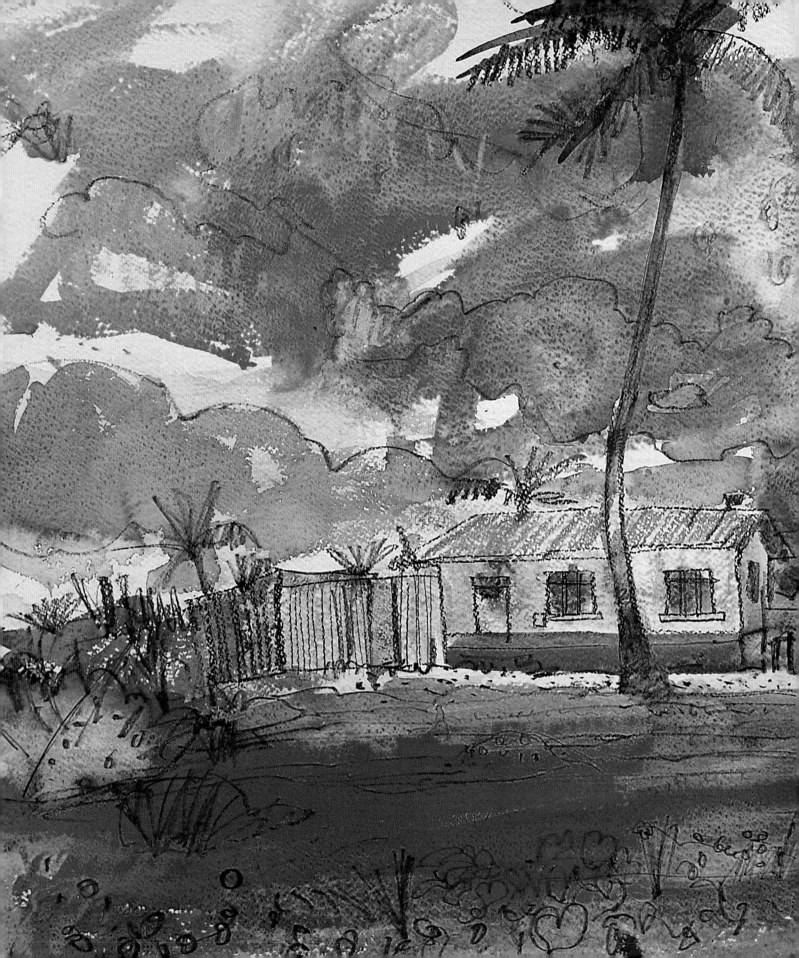

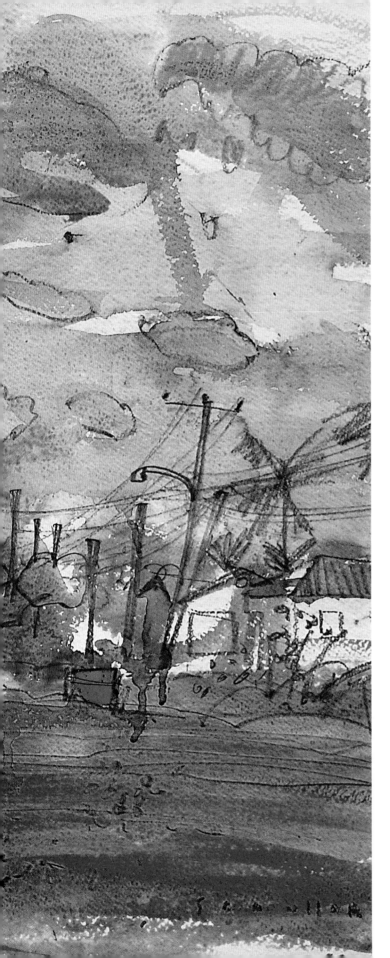

Hot climates

I haven't yet managed to capture the colour of this landscape; there are moments when I'm appalled at the colours I'm having to use, I'm afraid what I'm doing is just dreadful and yet I really am understanding it; the light is simply terrifying.

Claude Monet (1840–1926)

For me, watercolour is more of a warm weather medium simply because this means it dries faster, I can work more quickly with over-glazing, and all this generally suits the rapid way I work. But warm weather is fine up to a point: there are times when it is just too hot. I recall one such occasion in the south of France when the temperature soared into the region of 40°C (104°F); the unprecedented heat caused hundreds to die. I remember, despite working in the shade and soaking the paper with a sponge, that the paper (which I had also stretched) was bone dry as soon as I started painting and when I put a mark on the surface, it too dried instantly. One learns to adapt, so I had taken a small water 'mister' with which to constantly spray the paper: it wasn't perfect, but it did help. I also remember dropping a brush on the ground and, having forgotten about it, picked it up later on by the ferrule and burned my fingers!

Chattel Houses, Barbados
Watercolour, Berol Karismacolor water-soluble pencil, oil pastels, Saunders Waterford 300 gsm paper 53 x 71 cm (21 x 28 in.)
Collection of the artist
Just after finishing this painting, the heavens opened and a fierce squall gathered momentum... and I had to run for cover. You can see from the strange shape of the palm tree in the centre that strong winds and storms are a common element of the weather in this part of the world.

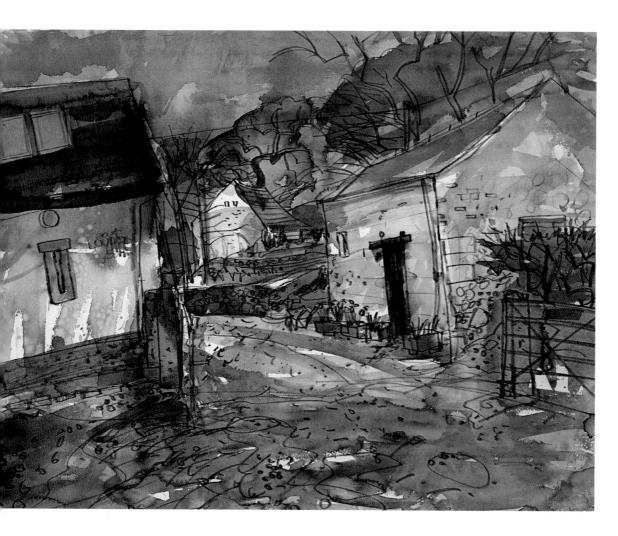

Gate at Loudounhill

Watercolour, Berol Karismacolor water-soluble pencil, oil pastels, Waterford 300 gsm NOT paper 53 x 71 cm (21 x 28 in.) Private collection
Another example of bad weather making a good subject for a painting. This time I was a lot closer to home. This was really an exercise in grey – not quite 'fifty shades', but not far off! I liked the dark, leaden sky with the slate-grey roofs in front. Working with a limited palette of Payne's grey, French ultramarine, yellow ochre and alizarin crimson, I punctuated the grey with pings of strong red and blue.

Another drawback of painting outdoors is human curiosity, so whenever possible I try to be as inconspicuous as conditions allow by having my back to a wall or hiding in a discreet corner. Even that doesn't deter the curiosity of some individuals, who will do anything to get a look at what you are doing. I remember my dear artist friend, the late George Devlin, telling me of a similar instance when a man started to annoy him so much that George, with adept precision, started to flick his brush (in the manner one casually does when expelling excess paint) in the direction of this individual: he was soon heading for the hills from whence he came.

Painting in India is another ball game entirely. No matter where you are, or how inconspicuous you try to be, I guarantee that within a few minutes, you will have a crowd of curious onlookers wanting to know what you are doing. Indians are very polite and courteous people and after the initial shock of having a large audience, you soon get used to the gaze of a dozen pairs of eyes or more waiting for the next brushmark to hit the paper. Constantly changing light, insects, curious humans and the elements certainly all conspire to make the *plein-air* painter's life an interesting one!

Bad weather

It's raining again and once again I have to put the studies I have started to one side... I am witnessing a complete transformation taking place in nature, and my courage is failing as a result.

Claude Monet (1840–1926)

At the other extreme, inclement weather can also be really exciting to paint (although Monet didn't seem to think so) – just look at the paintings of J. M. W. Turner. As long as you are well prepared for the conditions you are likely to meet, it shouldn't be too great a problem, and you can always shelter inside the car temporarily. Check the weather forecast the night before a planned trip to determine whether you will need a sou'wester, an umbrella, wellingtons, ski jacket and salopettes or perhaps just a light jacket. However, if my home country of Scotland is your painting destination, my advice is to take all of the above, as we frequently are exposed to four seasons in one day.

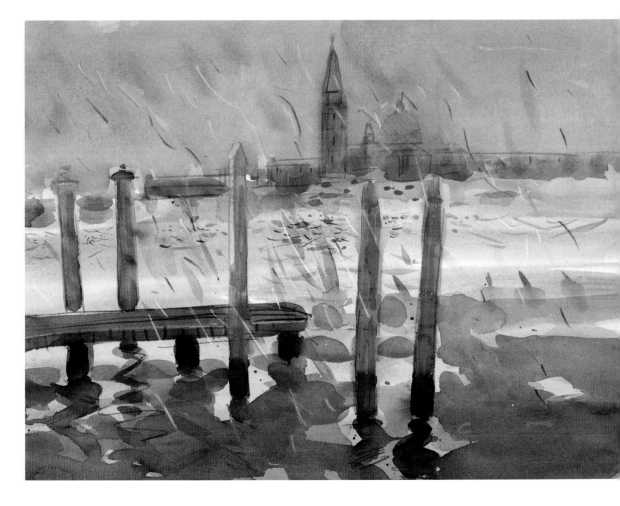

Rain, Venice Lagoon, Italy

Watercolour, Berol Karismacolor water-soluble pencil, oil pastels, Saunders Waterford 300 gsm paper 53 x 71 cm (21 x 28 in.) Collection of the artist

I started this in the rain but abandoned it and finished it back in the studio from memory.

The Church, Mexilhoeira Grande, Algarve, Portugal

Watercolour, Berol Karismacolor water-soluble pencil, oil pastels, Fabriano Artistico 300 gsm Rough paper 53 x 71 cm (21 x 28 in.)
Private collection

I enjoy trying to fit figures into my paintings. Sometimes they literally just walk into the view and it's a mad scramble to place them in the work, but more often than not I have to try to memorize what I have just seen. This painting, however, was a bit of an exception. I was looking at the church and its various surrounding trees and planning in my head where it was all going to fit on the paper, when out of the blue a little lady appeared. She looked so interesting that she was the first thing I put into the painting and everything else was built around her. The other figure appeared towards the end of the painting session.

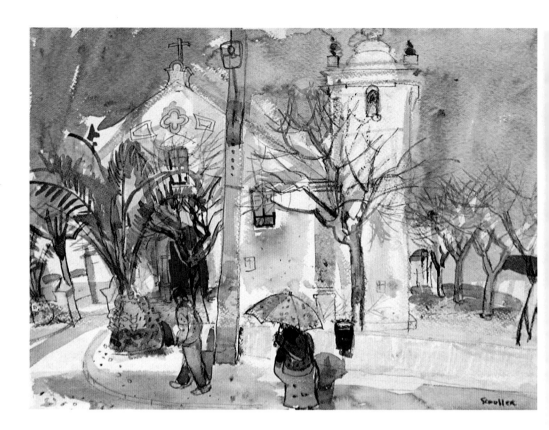

Boats and Nets, Almuñécar, Spain

Watercolour, Berol Karismacolor water-soluble pencil, oil pastels, Fabriano Artistico 300 gsm Rough paper 53 x 71 cm (21 x 28 in.)
Private collection

In choosing this subject, I was drawn by the way that the lines of the boats echoed the lines of the strata in the background rock formations.

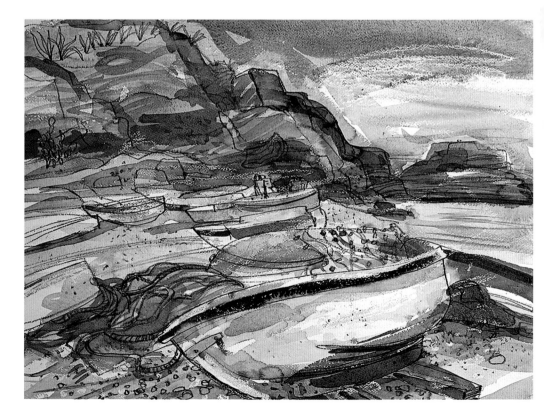

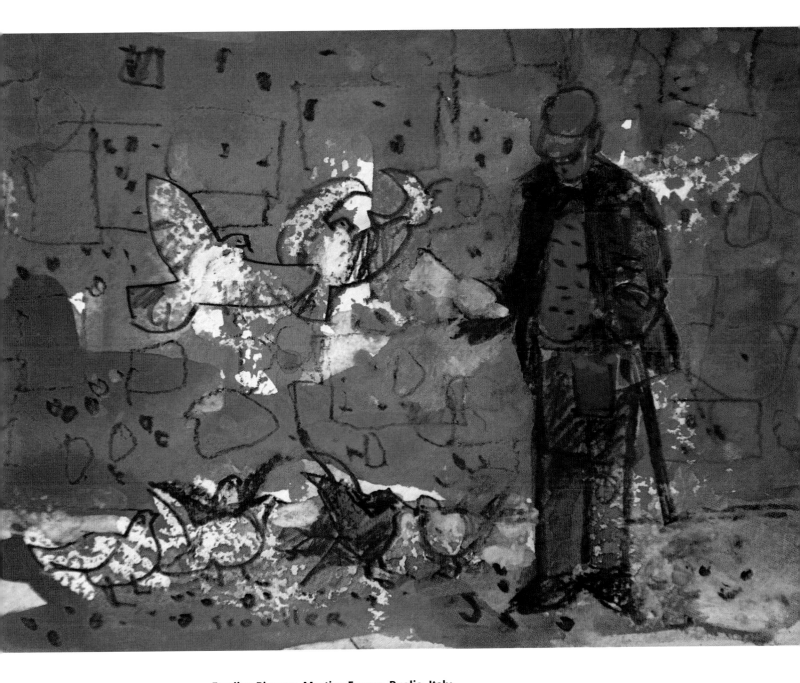

Feeding Pigeons, Martina Franca, Puglia, Italy

Watercolour, Chinese white, Berol Karismacolor water-soluble pencil, oil pastels, Saunders
Waterford 300 gsm NOT paper 10 x 15 cm (4 x 6 in.) Private collection
This study was painted in the studio from line drawings and notes I had made on the spot.
I saw an old man feeding pigeons in Puglia, and I made several small oil paintings plus a
large, square, 1.8-m (6-ft.) oil on the same theme. That is why I find it important to carry a
sketchbook and keep looking and jotting down ideas that could be used at a later date. It is
amazing how quickly you can build up a personal encyclopaedia of ideas.

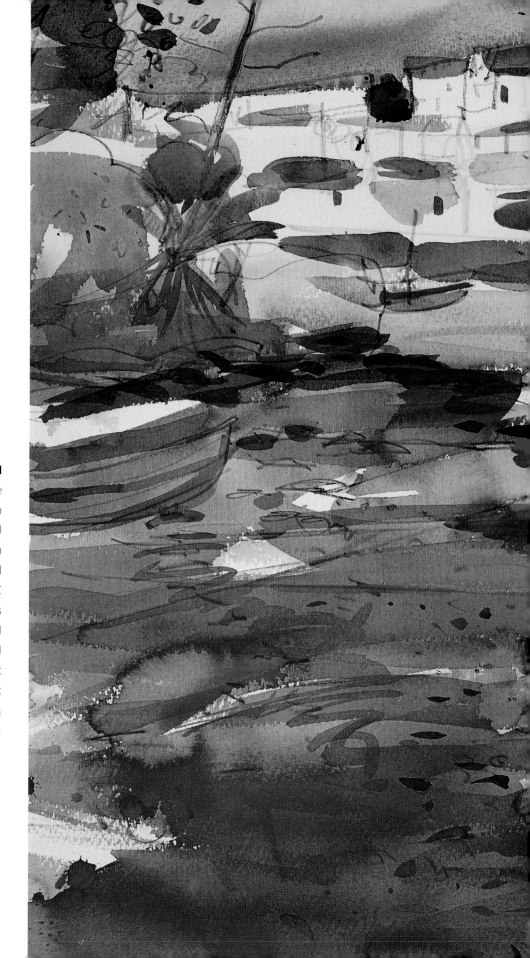

Tethered Boats, Ferragudo, Portugal

Watercolour, Berol Karismacolor water-soluble pencil, oil pastels, Saunders Waterford 300 gsm NOT paper 53 x 71 cm (21 x 28 in.)

Private collection

Working outdoors can be fraught with all kinds of perils. In this instance it was the 34°C (93°F) Algarve heat compounded by voracious sandflies, making it a test of concentration and endurance. This was a subject I had painted before, but the aforementioned mix made it a different painting altogether – executed at a different speed, a different time of day, in a different frame of mind, and so on.

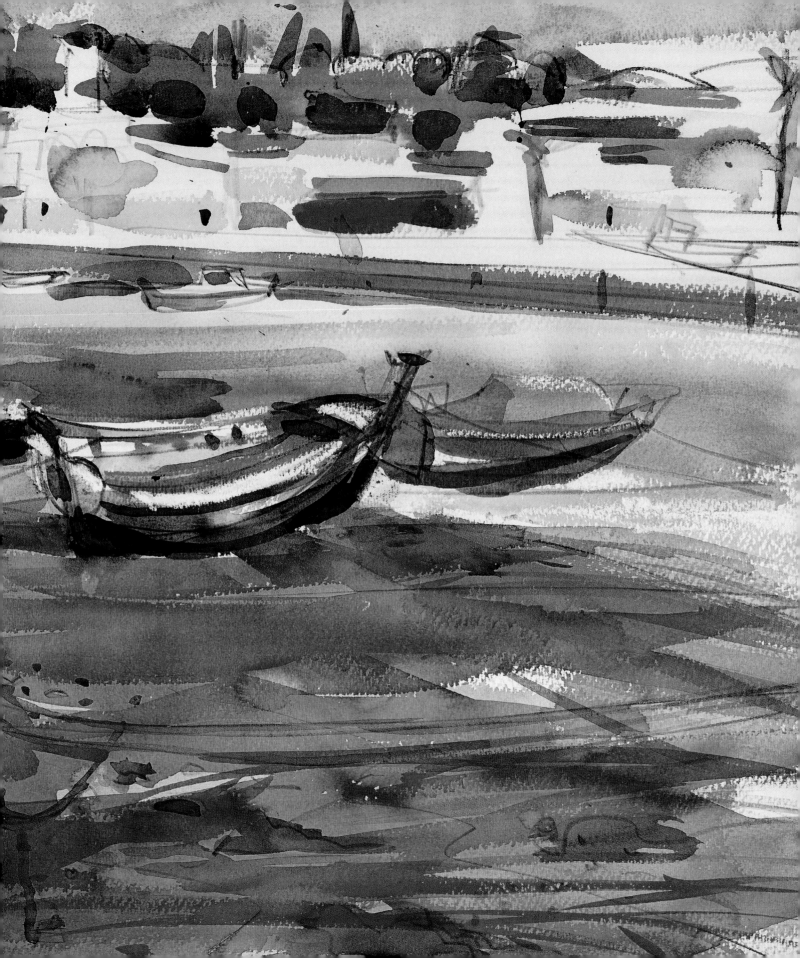

Demonstration: Octopus Boats, Santa Luzia, Algarve, Portugal

Introduction

As I have mentioned before, painting *en plein air* can present the artist with problems such as the weather, terrain, or intrusive onlookers. However, on this occasion it was the incoming tide that posed the challenge. I started painting the boat, emptied of the clay pots used for catching octopuses, while there was still a fair bit of beach at my back, but I soon became aware of the lapping water behind me getting ever closer. Once again, speed was of the essence if I was to make anything of this subject.

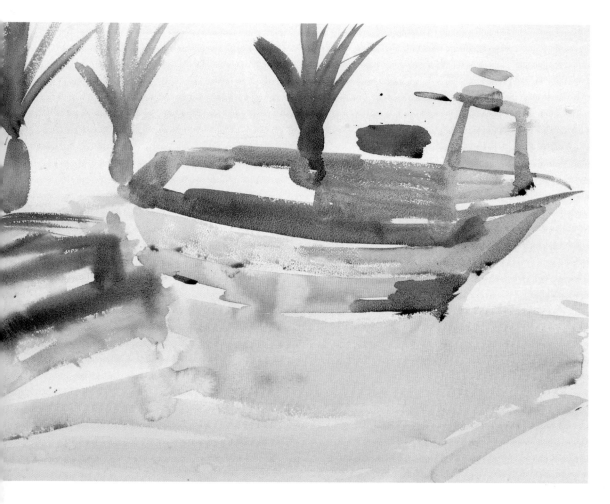

Materials

- Oil pastels: white, cobalt blue, grey, cerulean blue.
- Berol Karismacolor water-soluble pencil.
- Watercolours: cerulean blue, French ultramarine, yellow ochre, viridian, olive green, cadmium scarlet and cadmium yellow pale.
- Saunders Waterford 300 gsm NOT paper, 53 x 71 cm (21 x 28 in.).

Stage 1

I started by using white oil pastel in the sky to mark the clouds and add textural interest, then I blocked in the main big shapes with thin washes of colour.

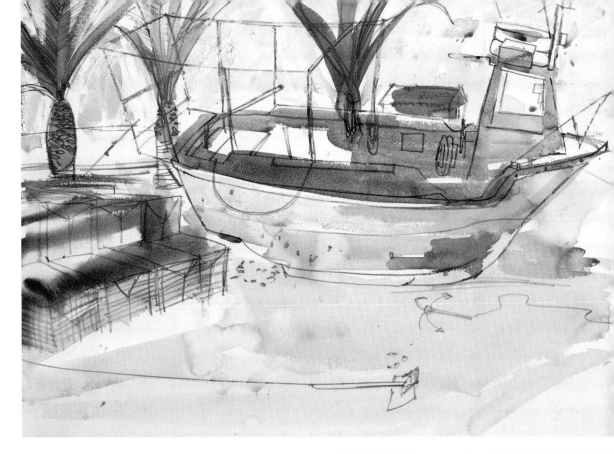

Stage 2

With my pencil, I started to draw the main parts of the boat, palm trees in the background and any other elements I thought added to the overall composition. Before starting the painting I had a good wander around the boat for ten minutes or so, eyeing up different possible solutions. I decided on this composition, as I rather liked the pattern made by the palm trees in the background, counterbalanced by the boat in front. I also added a few touches of oil pastel here and there for texture and surface interest.

Stage 3

Lastly, I beefed up the colour with washes of more intense pigment and deepened the shadows under the boat to make it 'sit' on the beach.

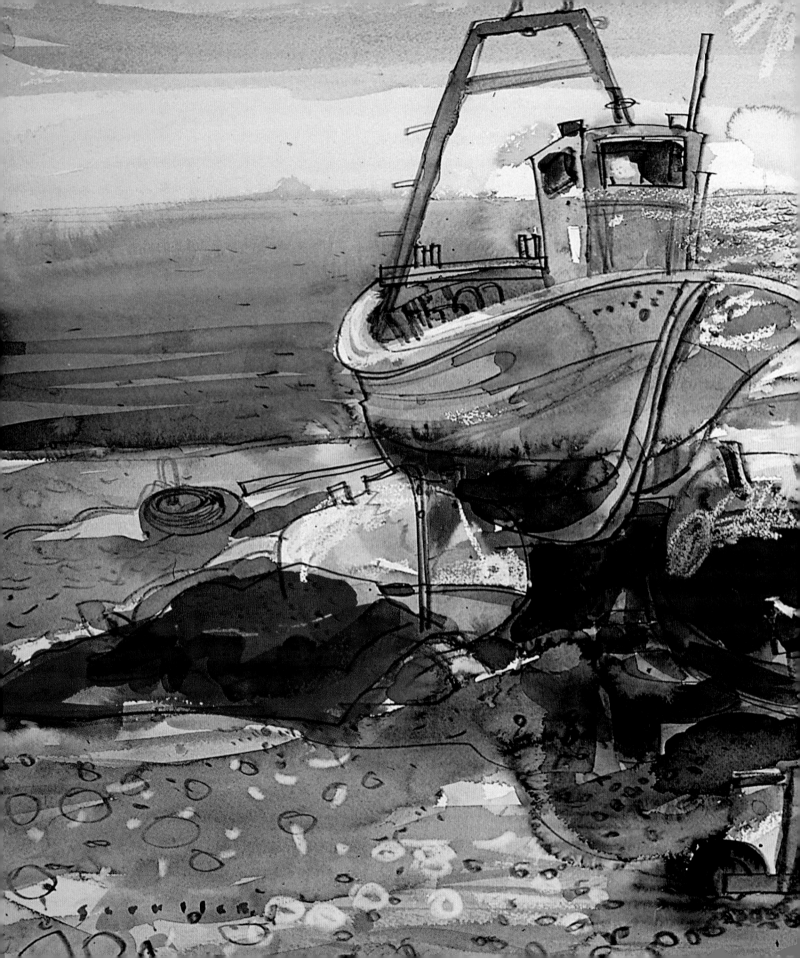

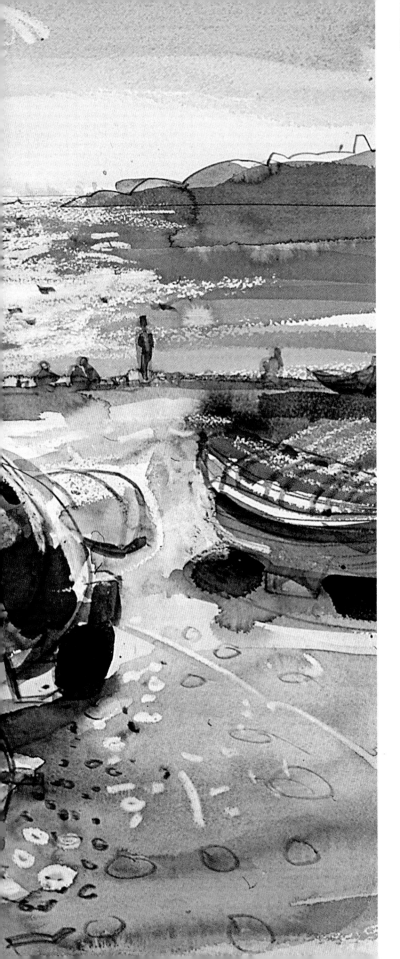

Creating light

Draughtsmen may be made, but colourists are born.
Eugène Delacroix (1798–1863)

While doing research for this book I have looked at hundreds upon hundreds of images of my work: in photographs, transparencies (all sizes and types) and digital format. Throughout the years, my fascination with drawing, colour and light has been a constant. Even as a student at Glasgow School of Art, these were obviously things that interested me greatly, reflected in the artists I admired then and still admire to this day.

Boats, Contre-Jour, Algarve, Portugal

Watercolour, water-soluble pencil, oil pastels, Saunders Waterford 300 gsm NOT paper 53 x 71 cm (21 x 28 in.) Private collection

The attraction here was the dazzling, shimmering light reflected from the sea in contrast to the elegant shape of the boat, which was almost in silhouette. The cool blues of the sea and sky complemented the warmer blues in the boats. The splash of red in the foreground boat provided a striking contrast to what is otherwise a cool painting. The first marks on this painting were done with a white oil pastel, where I tried to place what would eventually be the bright, dancing light on the distant sea. I used a limited palette of French ultramarine, cerulean blue, cadmium yellow deep and Payne's grey.

Colour sense is very personal – everyone has favourite colours – and it is something that is usually developed over a long period of time. A good colour sense is also something that some people, no matter how hard they try, will never achieve, so I reckon it is something we must have within our soul and in our genes!

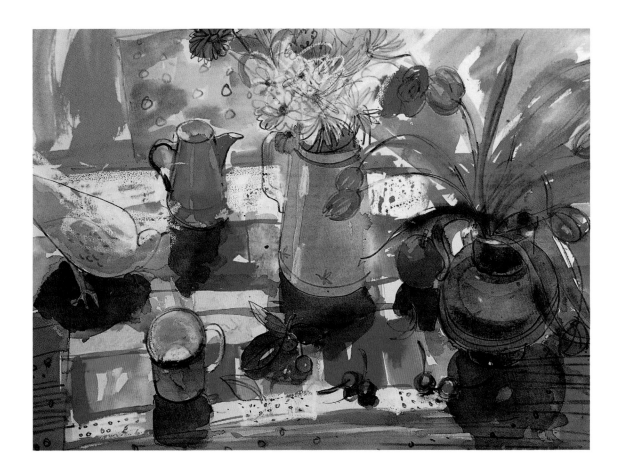

Tulips, Dove and Daisies

Watercolour, Berol Karismacolor water-soluble pencil, oil pastels, Saunders Waterford 300 gsm NOT paper 53 x 71 cm (21 x 28 in.) Private collection

This is a more recent work, which I sold at the annual exhibition of the Royal Scottish Society of Painters in Watercolour in Edinburgh a couple of years ago. I bought the tea towel in a market in Puglia, attracted by its strong colour and pattern. It became the platform for this still life, which is one of many I have set up on the studio floor in recent years. I liked the sharp contrast between light and dark, and

while trying to keep the contrast strong, I still wanted the shadows to be colourful. I started by quickly blocking in the light areas with a white oil pastel, trying to gauge as accurately as possible where the light areas were going to be (this was tricky, as I was working with white oil pastel on white paper). Of course I could have lightly pencilled in the objects, but for me that defeats the purpose of trying to inject life and spontaneity into a work. I then laid on some light washes to gauge where all the objects would be placed. Mistakes and corrections were left in, as I think it adds to the richness of the piece.

I visited the 'Late Turner' exhibition at the Tate Britain Gallery in London and was fascinated to read, in some of the footnotes, that when Turner was painting the landscape he nearly always painted *contre-jour*, or against the light. It is not always apparent at first glance, but when you look carefully at his work it becomes obvious. Looking at my own work, this is something I tend to do a lot as well. Many of the Impressionists in the late nineteenth century also used it to great effect in their paintings.

Watercolour, for me, is an ideal medium to portray light: it is translucent, it can be overlapped, intermingled with different colours, graduated seamlessly with limpid washes, and can generally simulate the way that light behaves.

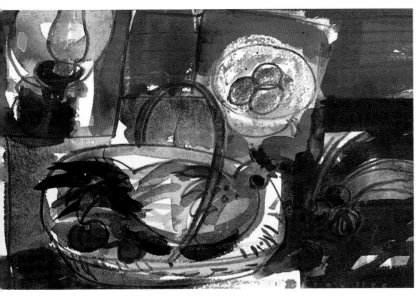

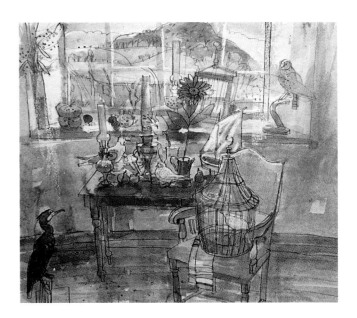

Floor Arrangement: Pink and Yellow
Watercolour, Berol Karismacolor water-soluble pencil, oil pastels, Saunders Waterford 300 gsm NOT paper 10 x 15 cm (4 x 6 in.) Private collection
In recent years I have used the studio floor as a backdrop for still lifes – partly due to a feeling that I had (for a while at least) exhausted tabletop still lifes – as I wanted to do something a bit different.

Birdcage and Chair
Watercolour, Berol Karismacolor water-soluble pencil, oil pastels, printmaking paper 91 x 101 cm (36 x 40 in.) Private collection
This was painted on a very large sheet of printmaking paper (the name of which escapes me), which was a lot more absorbent than watercolour paper due to less size being used in its production. I enjoy, and feel more at home, painting on a large scale, in both oils and watercolours. Even as a student, I was painting on canvases that were 1.82 m (6 ft) square. I enjoy swinging a brush and feel less inhibited working on a large ground. This still life is comprised of studio clutter and cherished objects set against a studio window; I also included a bit of distant autumnal landscape.

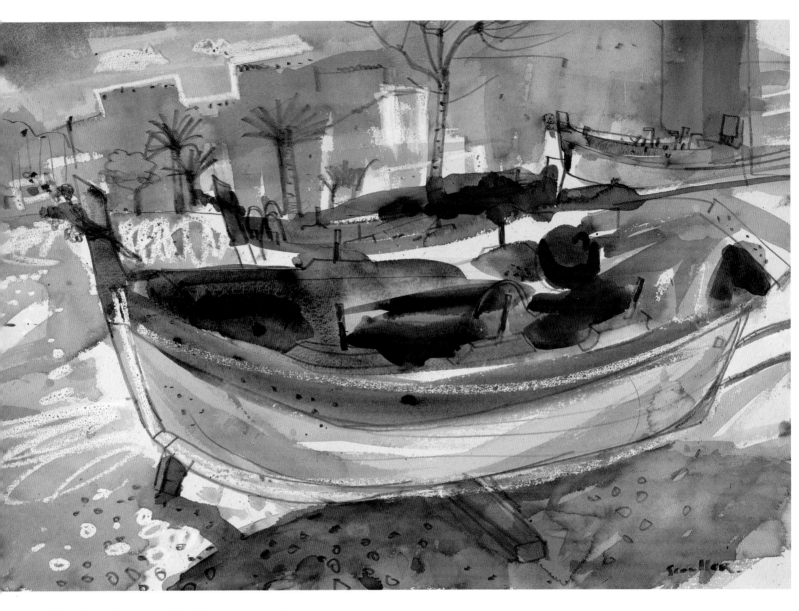

Fishing Boat, Cagnes-sur-Mer, France

Watercolour, Berol Karismacolor water-soluble pencil, oil pastels, Waterford 300 gsm NOT paper 53 x 71 cm (21 x 28 in.) Collection of the artist

The small seaside town of Cagnes-sur-Mer and its adjoining fishing port of Cros-de-Cagnes on the beautiful Côte d'Azur have provided me with an abundance of painting material over many decades. The clarity of light is amazing and is the main reason it became the destination (and in some cases the home) of many famous artists, especially during the era of the Impressionists. The port has been used as the location for many a motion picture; sadly, in recent years, progress has reared its ugly head and the old port has lost a bit of its original charm. However, with a bit of careful editing, it is still possible to find things of interest to paint. This group of boats attracted my attention and curiosity, firstly for the splash of strong colour they made against soft-coloured sand and also because of the curious little bunch of flowers attached to each bow... a good luck charm, perhaps?

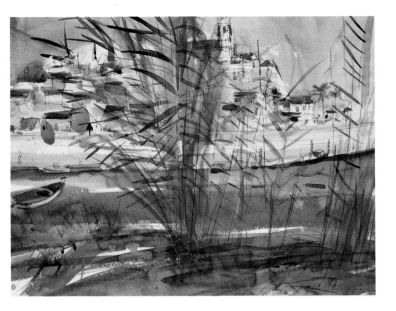

Beach Bamboo, Ferragudo, Algarve, Portugal

Watercolour, Berol Karismacolor water-soluble pencil, oil pastels, Saunders Waterford 300 gsm NOT paper 53 x 71 cm (21 x 28 in.) Private collection

This is a favourite spot, which I have painted many times over the years. Revisiting it and wanting to give it a different twist, I decided to paint the old town across the inlet as glimpsed through a thicket of tall bamboo stalks swaying in the breeze. The breeze was a blessing, as the sun and sandflies were both ferocious! A few touches of white oil pastel nailed the position of the old church steeple and a number of the whitest buildings. I then floated on some light washes to define the sky and the shape of the town's skyline, and also picked out some of the red tiled roofs. Next, I laid heavy puddles of stronger washes for the sea, beach and foreground. At this point, I drew in the basic shapes of some of the buildings and boats and then finally put in the bamboo, using a rigger brush for the stalks and a small sable for the leaves.

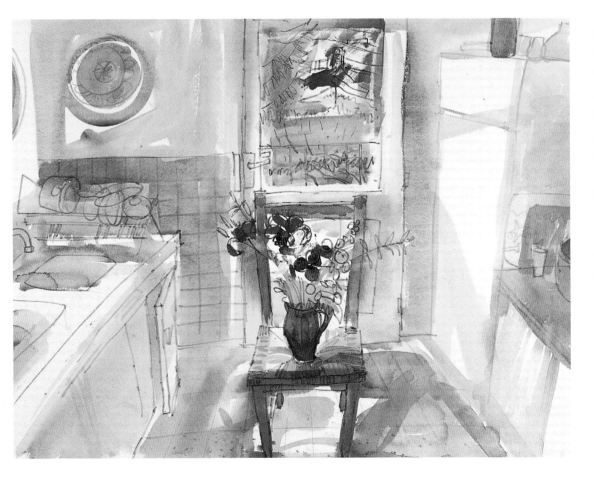

Felicity's Kitchen, Collioure, France

Watercolour, Berol Karismacolor water-soluble pencil, oil pastels, Saunders Waterford 300 gsm NOT paper 53 x 71 cm (21 x 28 in.) Collection of the artist

The whole kitchen was flooded with bright Mediterranean sunlight and this was what I was trying to capture in this painting – a feeling of light suffusing the little room. I made several paintings of Felicity's kitchen – Felicity is a very good friend of ours, and a brilliant cook – and then with this, the final work, I put some flowers on a chair to give it a focal point and a splash of colour.

Saturated colour

The following three paintings were all done in the studio, either from memory or from drawings made on the spot. My love of colour has led me to do many of these 'colour studies', where I have exaggerated the colour. I suppose these are not really paintings of boats or whatever: they are just an excuse to have fun with colour.

Colour is my day-long obsession, joy and torment.

Claude Monet (1840–1926)

With regard to colour saturation when working with watercolours, it is well worth remembering that when wet, the paint will appear to glow and look more intense, more saturated – this is one of the peculiarities of watercolour. However, it will lose some of this intensity when dry. It's better to recognize this before you start and add a little more paint into the mix to achieve the desired effect.

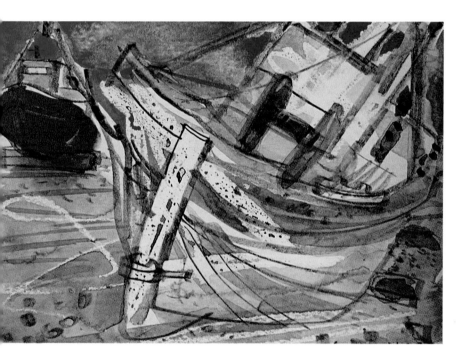

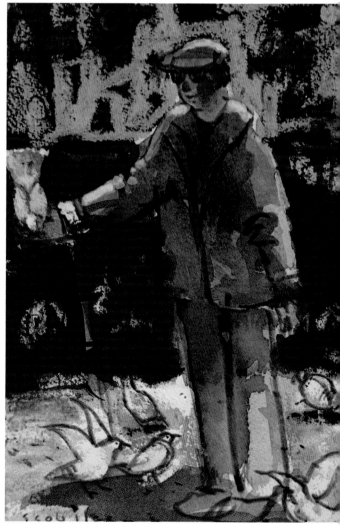

Beached Boats, Almuñécar, Spain

Watercolour, Berol Karismacolor water-soluble pencil, oil pastels, Daler-Rowney line and wash board 7 x 12½ cm (3 x 5 in.) Collection of the artist
I was playing around with colour and texture in this painting (and *Blind Man*, right). Here I used a wax resist to describe the weathering on the boat. In *Blind Man* I used a pink oil pastel on top of watercolour to make the colours 'pop' a little.

Boatyard, Guilvinec, Brittany, France

Watercolour, Berol Karismacolor water-soluble pencil, Arches Rives printing paper 121½ x 80 cm (48 x 31½ in.) Collection of the artist
Many years ago, I bought various packets of paper from John Purcell in London – a mixture of watercolour paper and printing paper. I wanted to paint on a large scale, larger than the approximately A1 size that stores normally stock, so he sent me some packets of printing paper, which looked just like watercolour paper but behaved entirely differently.

The one I used here looks a bit like a Rough watercolour paper, but because of the way size was applied, it is much more absorbent and so required a slightly different approach. I had to paint with a more wet-into-wet technique and soak the paper thoroughly before commencing the work. I also loaded the brush with extra pigment, as this type of paper tends to 'dull' the colour more when it dries. I enjoyed using this paper and did some successful paintings on it.

Blind Man with Doves

Watercolour, Berol Karismacolor water-soluble pencil, oil pastels, Daler-Rowney line and wash board 15 x 10 cm (6 x 4 in.) Collection of the artist
This small painting (and *Beached Boats*, left) was made on watercolour board, which I like to use for work at this small scale. It means I don't need to stretch paper, plus I can buy a large board and cut it down into maybe eight small boards.

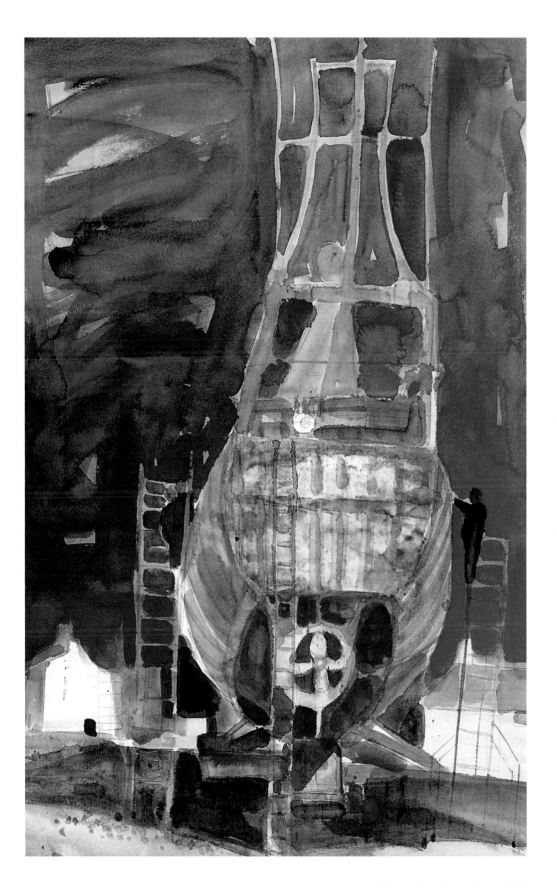

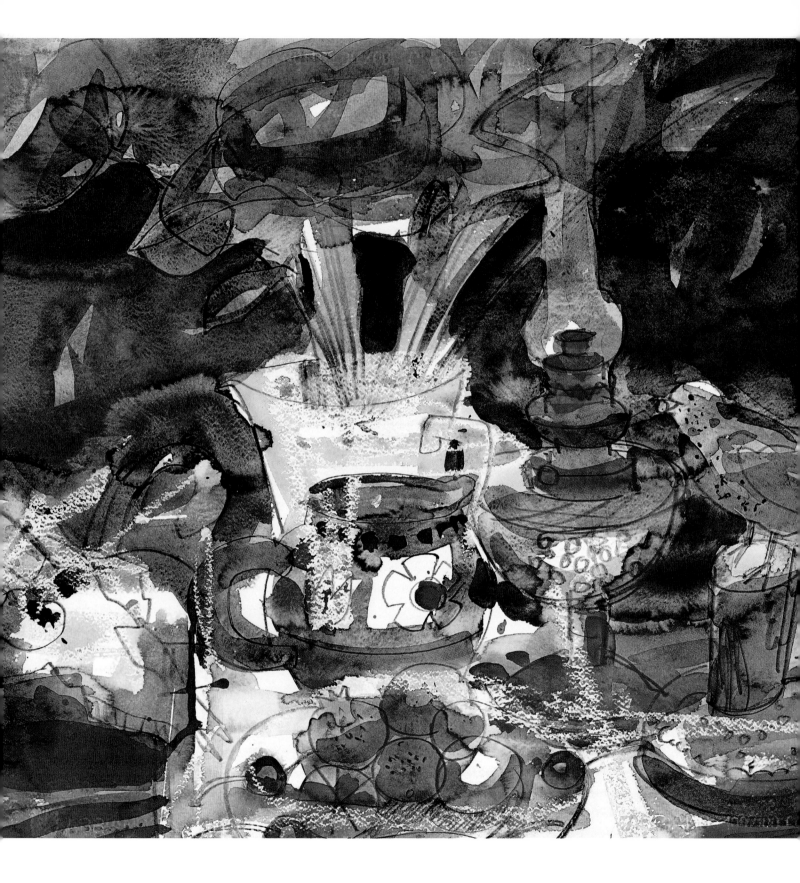

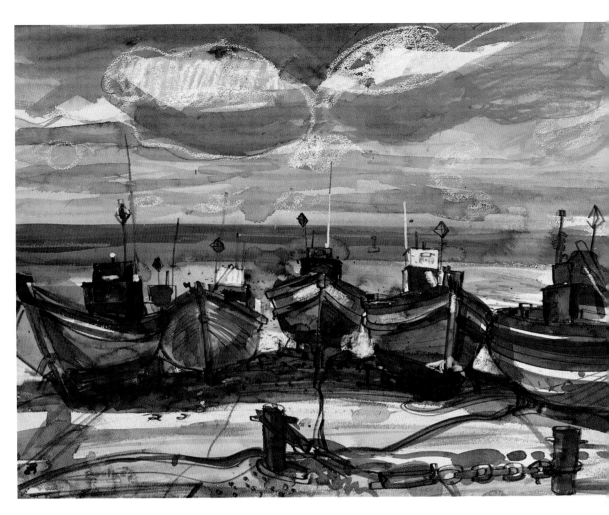

Still Life, Birds and Poppies

Watercolour, Chinese white, Berol Karismacolor water-soluble pencil, oil pastels, Saunders Waterford 300 gsm NOT paper 53 x 71 cm (21 x 28 in.)
Collection of the artist

This painting was all about the joy of colour. Objects have a habit of being shunted from pillar to post in the studio and can end up as an accidental still life – as here – whereby an arrangement strikes a chord with me as a paintable subject. In this instance the only things I added were the poppies. As you will probably note, my initial markings with the oil pastel were way off beam, but nonetheless I thought they still retained a certain something.

Boats on Slipway, Arniston, South Africa

Watercolour, Berol Karismacolor water-soluble pencil, oil pastels, Saunders Waterford 300 gsm NOT paper 53 x 71 cm (21 x 28 in.)
Private collection

I loved the way that these brightly coloured boats were lined up in a row on the slipway; curiously, the clouds were lined up in a similar fashion. The carefully drawn links in the chain repeated this pattern.

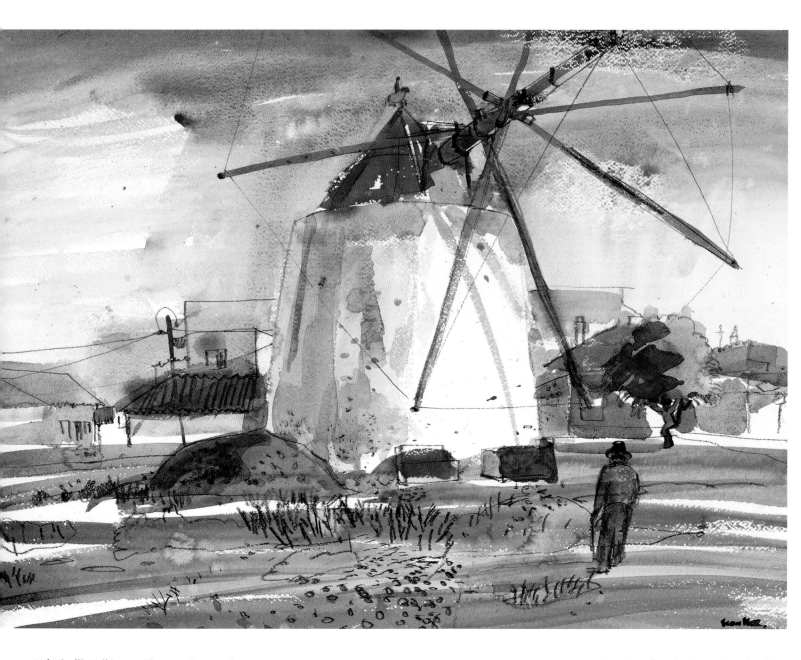

Windmill, Odiáxere, Algarve, Portugal

Watercolour, Berol Karismacolor water-soluble pencil, oil pastels, Saunders Waterford 300 gsm NOT paper 53 x 71 cm (21 x 28 in.) Private collection

An example of how the untouched white of the paper is used to good effect to describe form and light, as seen here on the sunlit side of an old windmill. Its strong shape, sitting in the middle of the painting, is offset by the old man wearing a traditional Portuguese fedora, who is walking away from me.

Boat Interior, Arniston, South Africa

Watercolour, Berol Karismacolor water-soluble pencil, oil pastels, Saunders Waterford 300 gsm NOT paper 53 x 71 cm (21 x 28 in.)
Private collection

I spent several days painting the boats in Arniston from all angles and directions. After each day's fishing trip, they would return to a different position on the slipway. On this occasion, I decided to get up close to a bright red one. It really became an exercise in red values, with a very restricted palette.

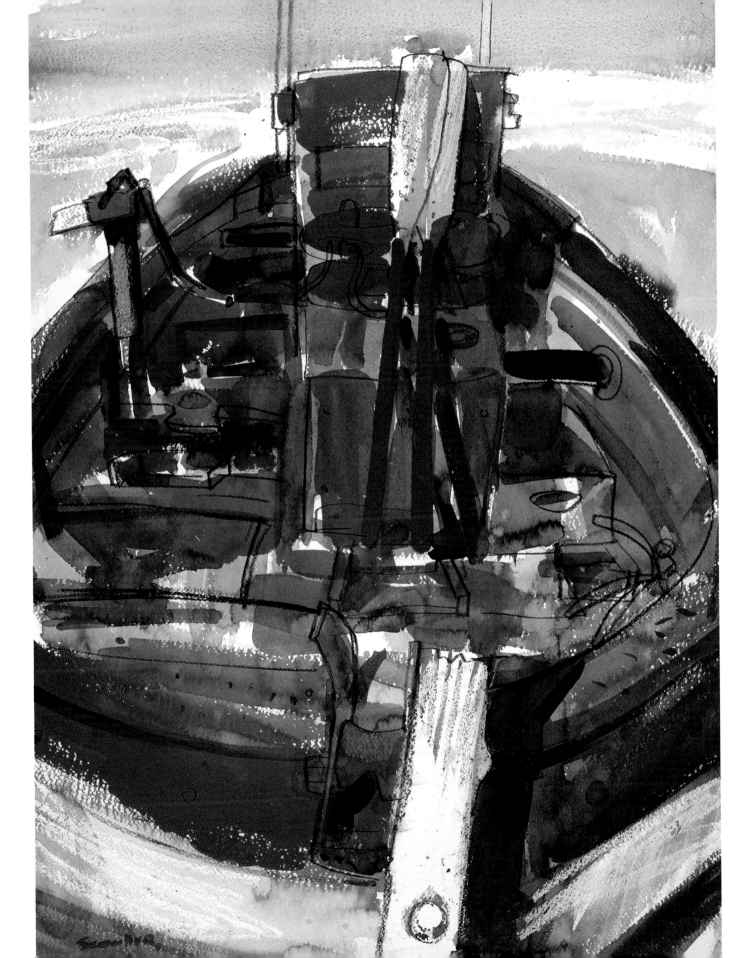

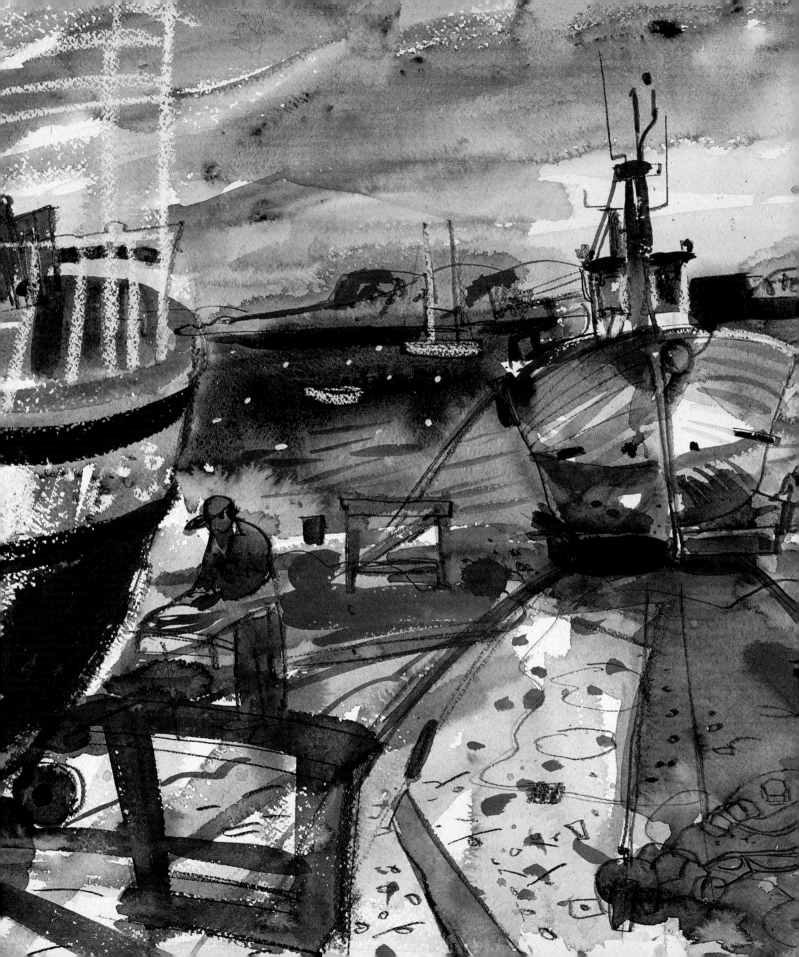

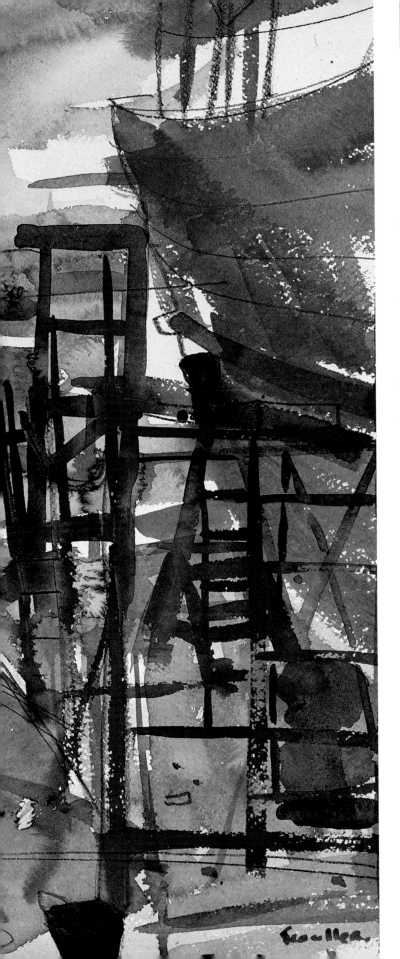

What is a suitable subject?

I associate my 'careless boyhood' with all that lies on the banks of the Stour. Those scenes made me a painter and I am grateful – that is, I had often thought of pictures of them before ever I touched a pencil.

John Constable (1776–1837)

Boatyard, Sagres, Portugal

Watercolour, Berol Karismacolor water-soluble pencil, oil pastels, Saunders Waterford 300 gsm NOT paper 53 x 71 cm (21 x 28 in.) Private collection

This was a great find after a long day's drive exploring the varied coastline of the southern Algarve. Heading west towards Cape St Vincent, the most south-westerly tip of Portugal, I stopped outside the town of Sagres and stumbled upon a small, very untidy boatyard – just my idea of painting heaven. One of the things that most excited me about this particular view was the scale of the figures against the boats, and the fact that I was facing out to sea also made it unusual. The majestic, almost monumental boats in their hard standings in the foreground contrasted interestingly with the small boats bobbing about in the distant water. I always feel that boats look at their best when out of the water, as you can see all of their beautiful, elegant lines right down to the keel; they are also easier to draw as they are not constantly changing direction. The figure on the left suddenly appeared when I had almost finished the painting; I put him in as I thought his scale and position were a useful addition to the overall success of the composition. This is one of the benefits of working *in situ*: unexpected things often happen in an ever-changing locus, a possibility that is ruled out when slavishly working from a photograph in the studio.

The expression 'Beauty is in the eye of the beholder' is most certainly true. What appeals to one artist may seem passé or dull to another. Who would have thought an artist could become famous for painting groups of bottles? The Italian artist Giorgio Morandi (1890–1964) did just that. Of course, he painted other subjects as well, but it is his wonderful bottle still lifes that he is best known for. Through a lifetime of looking, he found his own wonderful, poetic way of painting bottles with a delicately subtle muted palette.

I have often admired and envied artists who could make a great painting or drawing out of almost nothing, or out of the most mundane and unexpected subject matter. I have to confess that I don't possess that particular skill: I have to search and look hard for images that move me to paint or draw. The writing of this book has forced me, for the first time in a long while, to do an appraisal of my oeuvre and look at the repertoire of subjects that frequently recur in my work.

When travelling abroad I usually fill my car to the gunwales with oil paints and their supports (canvases and boards) and associated accoutrements, plus watercolours, paper, sketchbooks and drawing materials. It is a veritable mobile studio. Despite having a car full of lovely art materials, I still have to find something that moves me to paint and that is sometimes the really difficult bit. Having a strong idea usually results in a strong painting, but sadly the converse is so often true as well. I have sometimes driven around all day looking for that elusive subject, whether it's a fleeting moment of the weather's effect on the landscape or something more tangible, like a boatyard in Portugal or an ancient ruined farm in Provence. It is difficult to explain, but there is an almost instant recognition and an inner excitement when I discover a subject that has possibilities for producing a work or, better still, a series of works.

Ancient Oak, The Farm, Fayence
Watercolour, Berol Karismacolor water-soluble pencil, white oil pastel, John Purcell watercolour sketchbook (NOT) 30 x 42 cm (12 x 16½ in.)
Collection of the artist
Painted on an unusually overcast winter's day in this part of Provence, using a limited palette of yellow ochre, Payne's grey, cerulean blue, French ultramarine and cadmium scarlet.

Mas de Provence, Fayence
Watercolour, Berol Karismacolor water-soluble pencil, white & yellow oil pastels, John Purcell 300 gsm watercolour sketchbook (NOT) 30 x 42 cm (12 x 16½ in.)
Collection of the artist
This farmhouse both fascinated and attracted me to do a substantial body of work (mainly oils) over a number of years. On this occasion I did a number of colour studies in the sturdy Purcell sketchbook using a few colours including yellow ochre, Payne's grey, cerulean blue, French ultramarine and cadmium scarlet.

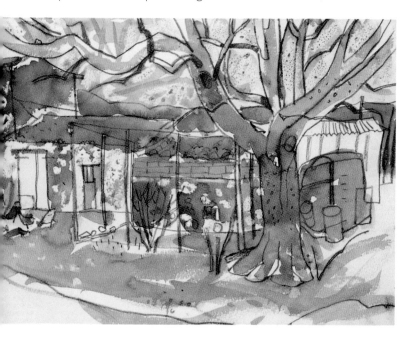

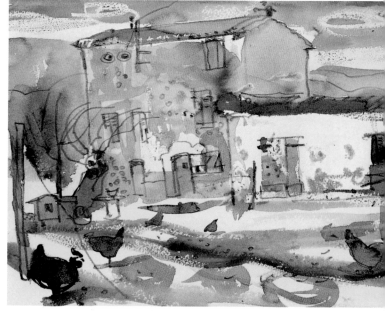

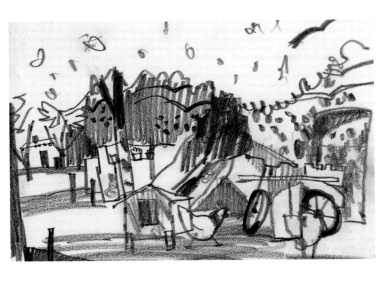
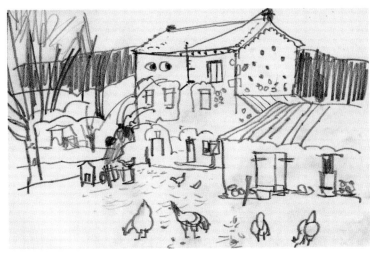

Farm Sketches, Fayence

John Purcell sketchbook, 30 x 42 cm (12 x 16½ in.) Staedtler clutch pencil 6B lead Collection of the artist
A series of quick sketches I made as I moved around the farm exploring compositional possibilities. It's hard to put into words the excitement experienced when a new subject presents itself, a subject where you can't wait to capture the essence of that first glimpse and endeavour to put it onto canvas or paper!

I recall only too well working in the Var region of Provence some 20 years ago. I spent a good few frustrating days painting things that didn't fill me with any great enthusiasm… and it showed in the end results. Subsequently, I was out in my car reconnoitring the somewhat parched countryside of late autumn near the famous town of Fayence, with a feeling of mounting anxiety, as I had a solo exhibition looming at the Billcliffe Gallery, Glasgow in the not too distant future. Suddenly, I spotted a beautiful *mas* (a particular type of farmhouse only found in Provence) sitting about 46 m (150 ft) back from the road. It had loads of clutter, an olive tree, outbuildings, rusting ancient farm machinery, farm animals, and an aged farmer and his wife busy with their daily chores. It was almost like a moment frozen in time, something from a bygone era. It was this painter's dream subject matter!

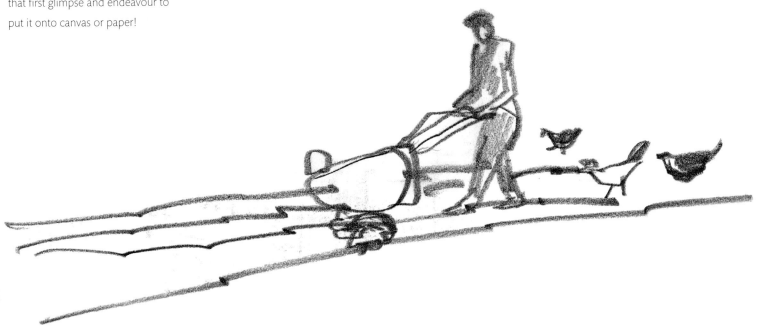

This turned out to be an amazing discovery for me and I returned to paint there for a number of years in succession, always finding something new that I hadn't spotted before. I became a familiar sight for Monsieur Antoine and his wife. Painting there each day for the rest of that first exciting month on their farm, I became less of an object of curiosity and more of a friendly distraction from their daily tasks. They were leading a very basic, simple, almost self-sufficient way of life, which is sadly disappearing rapidly in this part of France. In fact, one of the neighbours informed me that just a few years prior to my first visit, Monsieur Antoine had been working his field with oxen and a plough. On my last visit there about 12 years ago, I took my wife along to meet the couple, but alas discovered that Monsieur Antoine had died six months previously. He died harvesting in his beloved field, where he had toiled with devoted care, man and boy, for 60 years. I have never been back since – I think the magic would be gone.

It is of course also true that you do not need to travel to far-off locations to find exciting material to paint. Recently, I have done a number of drawings of fish being prepared in our kitchen: something I had seen a hundred times before, but suddenly a whole lot of new possibilities became apparent. For an artist, it is very important to keep an open mind as to what can make an exciting drawing or painting. There is an element of security about returning to a theme previously tackled, but you need to experiment with materials, process and composition, and take chances. With that newly gained confidence, you can progress to something more challenging – after all, successful painting is down to self-belief, self-confidence and personal vision, not to mention blood, sweat and tears!

Monsieur Antoine
Feeding his Hens
John Purcell sketchbook
30 x 42 cm (12 x 16½ in)
Staedtler clutch pencil 6B lead
Collection of the artist
In this quick sketch of Monsieur Antoine feeding his hens, the placing of the old oak tree frames the composition. I came back to this idea at a later date and made an oil painting with a similar composition and it was also painted *in situ*.

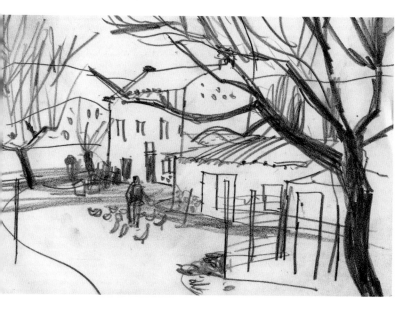

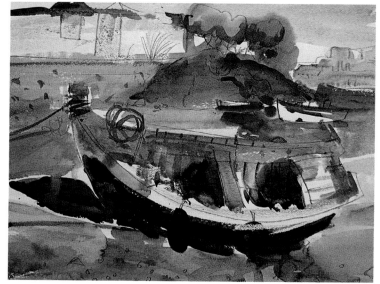

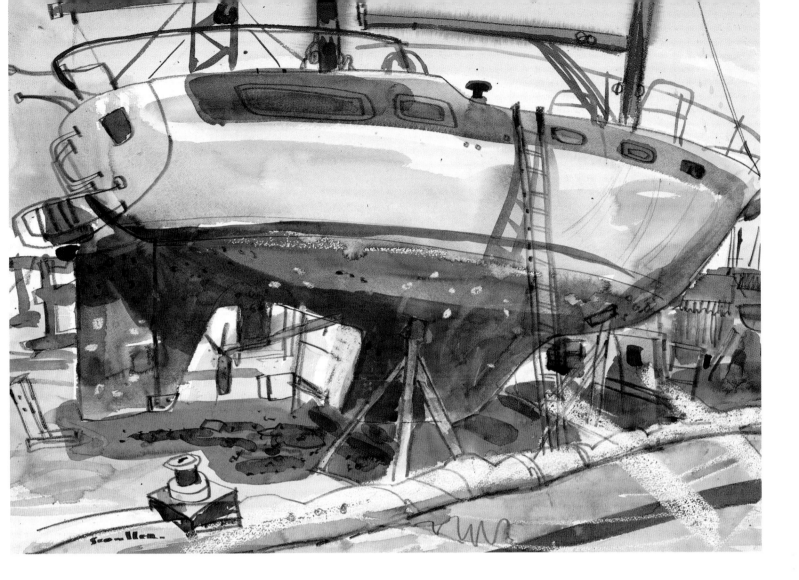

Beached Boat, Ferragudo, Algarve, Portugal

Watercolour, Berol Karismacolor water-soluble pencil, oil pastels, Saunders Waterford 300 gsm NOT paper 53 x 71 cm (21 x 28 in.) Private collection

The heady, intoxicating combination of the cerulean blue interior and the pale pink/magenta hull of this small fishing boat was too tempting to resist. The excitement of colour combinations has a definite effect on me and can often be the starting point for a painting. I made this particular colour study using a restricted palette of cerulean blue, ultramarine blue, magenta, alizarin crimson, cadmium yellow and Payne's grey. There is very little detail in this painting: it is all about the joy of colour.

Yacht, Port Vauban, Antibes, France

Watercolour, Berol Karismacolor water-soluble pencil, oil pastels, Saunders Waterford 300 gsm NOT paper 53 x 71 cm (21 x 28 in.) Collection of the Royal Bank of Scotland Group plc © 2016

For this painting, I initially made a few directional marks with a white oil pastel to place the boat and add texture to the rolled-up canvas sails in the foreground.

I then rapidly inserted some of the boat shapes with puddle-like washes of cerulean blue, adding ultramarine for the darker areas; alizarin crimson joined the previous mixes to create shadows under the boat. With different washes of yellow ochre, I indicated the position of the masts and finally, while the painting was still wet, I drew into it with a water-soluble pencil.

Boats and boatyards

I have painted in boatyards both in the UK and abroad throughout my career. In the early years I worked from Girvan to Clydebank and to Shetland, all in Scotland. Then abroad, from Cefalù in Sicily to Venice on mainland Italy, all around the Cape in South Africa and further east to the exotic island of Zanzibar. All have many things in common that attracted me, such as the elegant shapes of the boats out of the water, the colour, the general feeling of clutter, craftsmen at work... all are meat on this man's plate!

Fisherman Sorting his Lines, Alvor, Portugal

Cretacolor clutch pencil with a 4B lead, Daler-Rowney sketchbook 22 x 30 cm (8½ x 12 in.)
Collection of the artist

This study was drawn very quickly in a Daler-Rowney sketchbook; the smooth paper lends itself beautifully to work in pencil and fibre-tip pen. I liked the way the shadows hitting the fisherman described his form and created interesting shapes. I made a number of studies of this old mariner and some of his fishing companions.

Boat for Repair, Struis Bay, Western Cape, South Africa

Watercolour, Berol Karismacolor water-soluble pencil, oil pastels, Fabriano Artistico 300 gsm Rough paper 53 x 71 cm (21 x 28 in.)
Private collection

I remember having to attack this painting in the blistering heat of a South African summer. Even though I had given the paper a good soaking prior to starting work, the paint dried almost instantly. Working at breakneck speed certainly made for a lively drawing.

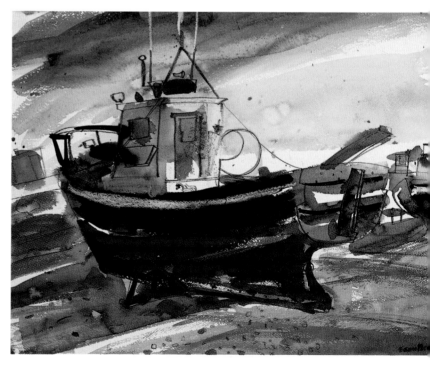

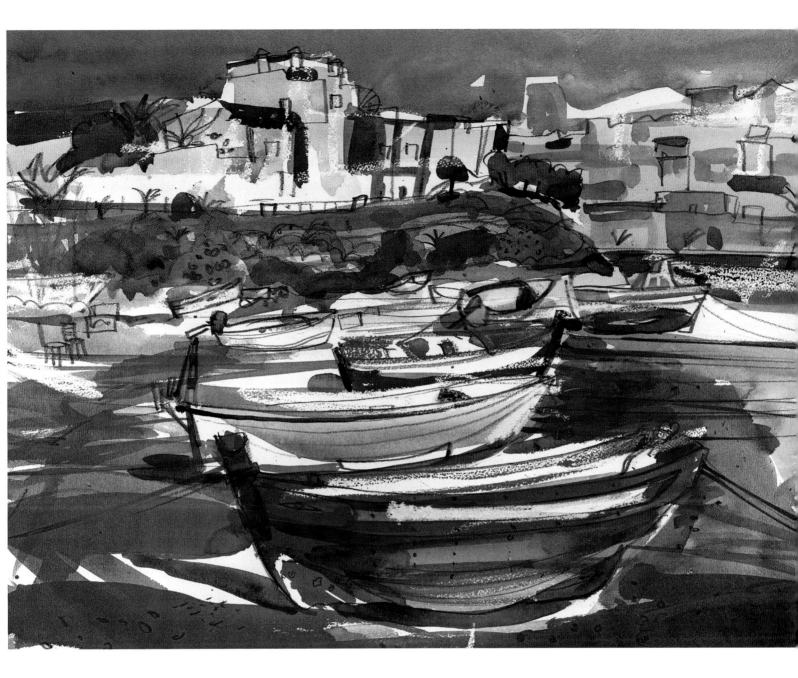

Small Fishing Boats, Ferragudo, Portugal

Watercolour, Berol Karismacolor water-soluble pencil, oil pastels, Saunders Waterford 300 gsm NOT paper 53 x 71 cm (21 x 28 in.) Collection of the Royal Bank of Scotland Group plc © 2016

Sometimes I let a single colour dominate a painting and build other colours around that 'theme' colour. Here the colour is yellow, which I used for the beach area, breaking it up with a variety of yellows made by mixing the original cadmium yellow with other colours and also by thinning it with water to give yet another dimension to the yellow. There has to be a colour balance in every painting, so I calmed the strong yellows with cool shades of grey and blue, using different mixes of ultramarine and Payne's grey.

Still life

The whole is more than the sum of its parts.

Aristotle (384–322 BC)

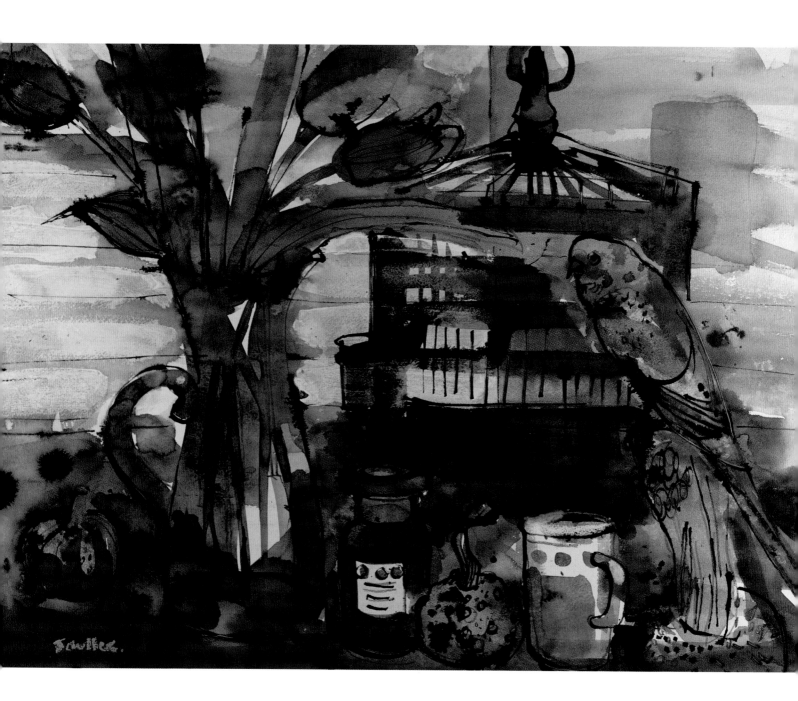

Subject matter can be found anywhere: in the kitchen, garden, supermarket, the immediate locale – in fact anywhere that attracts or excites you. To paraphrase Raoul Dufy's (1877–1953) famous quote, it is not what you paint that is important, but how you tackle it.

I prefer to 'find' still lifes rather than set them up. However, this is not always possible. That is why, over the years, I have built up a considerable collection of interesting objects found in street markets, antique shops, junk shops and various other places here and abroad. For one reason or another, these objects tend to get moved around the studio. Suddenly there will be an arrangement or combination of objects that is interesting and might make an exciting painting. In recent years I have been using the studio floor as the background for a lot of my still life work. Using the floor makes me look at the arrangement of objects from different angles and directions; I can also make a number of paintings from the still life that will all look very different.

The Green Parakeet

Watercolour, bamboo pen, Indian ink, white gouache, Saunders Waterford 300 gsm NOT paper 53 x 71 cm (21 x 28 in.) Collection of the artist
This was a bit of an experiment. I decided to try drawing into watercolour with a bamboo pen and ink whilst the watercolour was drying, in order to produce bleeding and feathering. The trick was to try to control the process and strike a balance between this and the colour washes. The strong black certainly emphasized the strength of the colours, with an almost stained-glass effect. I used some white gouache in the background as I felt the venetian blinds were tonally too dark,

Arrangement

Pencil with 6B lead, Daler-Rowney sketchbook 22 x 30 cm (8½ x 12 in.) Collection of the artist
This note from a sketchbook is a composition idea for a larger painting. The annotation at the bottom reads 'White table – splashes of colour' – this was what obviously struck me about the splashes of colourful objects against the stark white, newly painted (yet again) studio table.

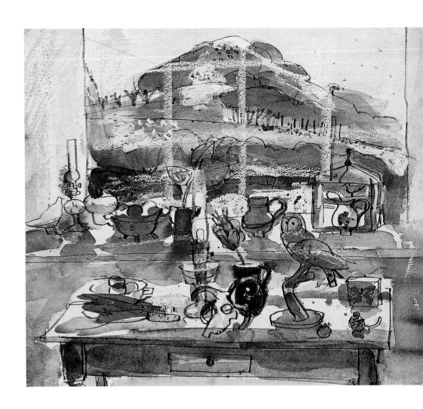

The Blue Table

Watercolour, Berol Karismacolor water-soluble pencil, oil pastels, Saunders Waterford 300 gsm NOT paper 53 x 71 cm (21 x 28 in.) Private collection
This painting (along with *Two Birdcages*) belongs to a series of works based on my studio window (with a view of the famous Loudounhill in the distance) and a painted table covered in some of my favourite collected objects. I have had the table for more than 30 years and during that time its colour has changed from red, to blue, yellow, green, black, grey and white. I give the table a lick of emulsion paint every so often; the colour will determine the mood of paintings and also give me fresh ideas about colour arrangements.

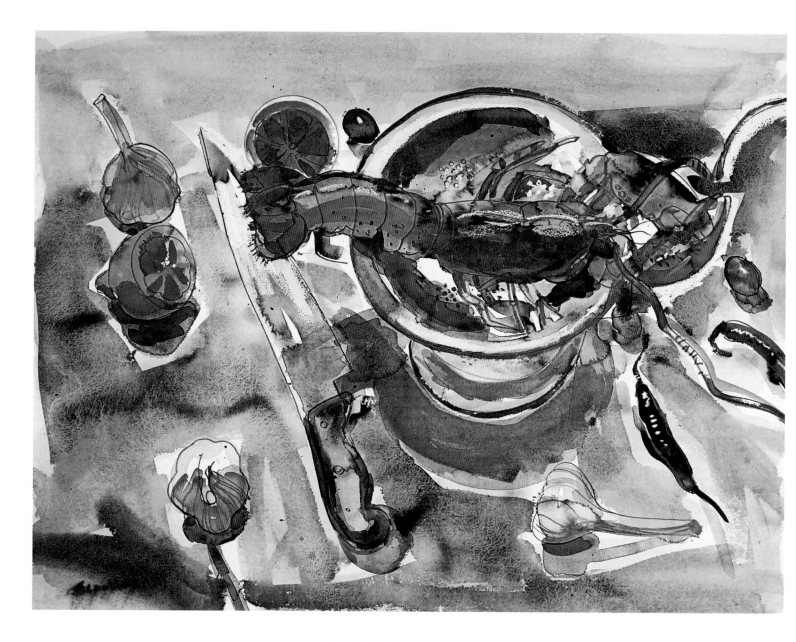

Lobster Lunch

Watercolour, Berol Karismacolor water-soluble pencil, oil pastels, Saunders Waterford 300 gsm NOT paper 53 x 71 cm (21 x 28 in.) Private collection

Lobsters are great things to paint – they are full of colour and texture and also make a great shape on the paper or canvas. In this painting, I set up a still life on the studio floor using a sheet of paper to hide the paint-spattered floor and added a few bits and pieces, including garlic and chillies, to continue the 'culinary' theme.

Still Life: Tulips and Hen

Watercolour, Berol Karismacolor water-soluble pencil, oil pastels, Saunders Waterford 300 gsm NOT paper 53 x 71 cm (21 x 28 in.) Private collection

The starting point for this painting was a bunch of supermarket tulips. I like to use seasonal fruit, vegetables and flowers, which can provide a much needed splash of colour in any still life arrangement. In this one I had to try to distinguish between the different hues of red – some warm and some cold.

Some watercolours are prone to what we call 'granulation', which is particularly noticeable in the blue jug. 'Granulation' means that when water is added the pigments separate from the binder and settle into the 'valleys' of the paper. As it dries in the valleys it leaves a grainy texture. The American paint manufacturer Daniel Smith produces a wide range of watercolours and the colour chart identifies which colours possess this granulation effect.

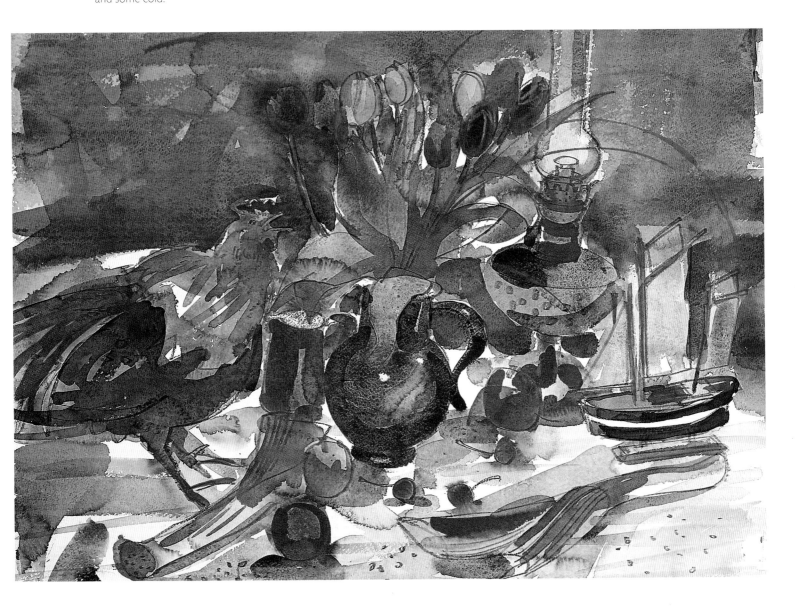

Landscape and urban landscape

I very seldom paint what most people would instantly recognize as a traditional landscape, and I shy away from anything that resembles a picture postcard scene. I would say most of my landscapes have been of the 'urban' variety and include quiet, shady streets at midday, farmland, buildings or a landscape that includes something tangible that I can get my teeth into.

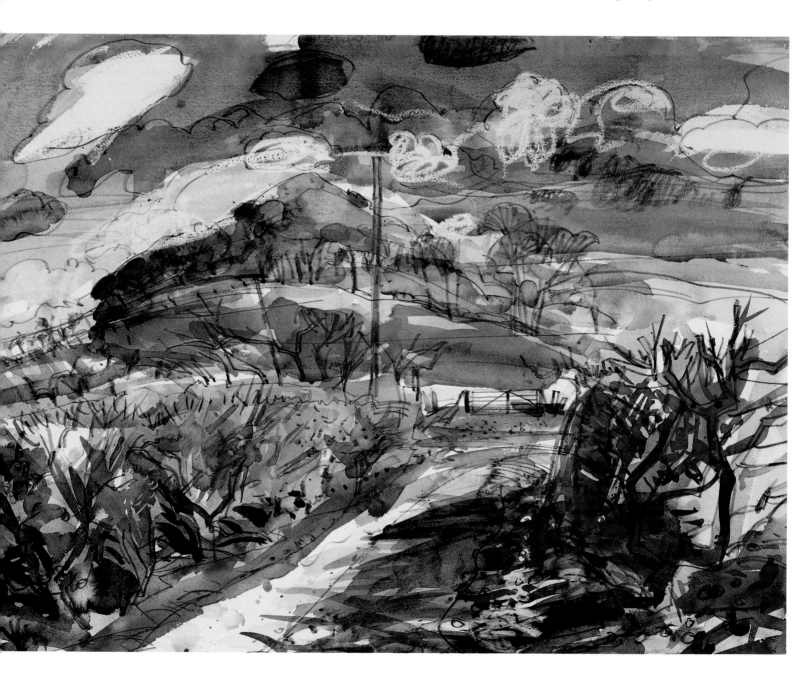

Hedgerows at Loudounhill

Watercolour, Berol Karismacolor water-soluble pencil, oil pastels, Saunders Waterford 300 gsm NOT paper

53 x 71 cm (21 x 28 in.) Collection of the artist

Windy days are a bit of a nightmare for any artist. Everything is moving quickly – trees, clouds and vegetation; easels, water buckets, paints and brushes can also take off into the far horizon. Watercolourists are probably more likely to run into difficulties than other artists, as the equipment tends to be lighter and the actual handling of the medium can demand a delicate touch because of its aqueous nature. This is where a good easel and some heavy weights come into their own. I have recently bought an easel that is ideally suited to watercolours. It is called a David Potter easel; it's not cheap, but ideally suited to watercolours and small oils too. It is well made, lightweight and has a broad twin central spar which is the key to its success for me, as it means that when you are drawing or leaning firmly on the board (especially at the sides), it doesn't wobble from side to side like other lightweight easels.

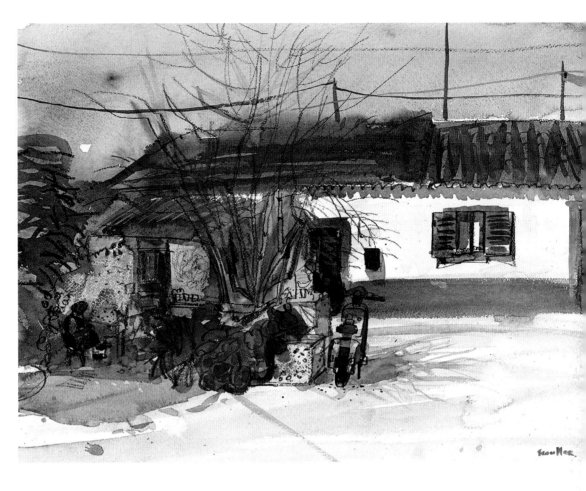

The Lacemaker, Falacho, Algarve, Portugal

Watercolour, Berol Karismacolor water-soluble pencil, oil pastels, Saunders Waterford 300 gsm Rough paper

53 x 71 cm (21 x 28 in.) Private collection

On all my painting trips I spend a lot of time searching out interesting subject matter. This particular tiny village in the Algarve was to provide me with several good days of painting. I did a number of different watercolours of this blue-painted house; however, what really caught my eye when I arrived was the old lady sitting making lace. Unfortunately, as I was setting up to paint, she disappeared inside her home. After a while she saw what I was doing and ventured out again, and I then made a number of studies of her at work. In this painting I made the focal point the area with the birdcage; halfway through painting, the old lady appeared and I managed to rapidly place her off-centre.

I returned to the village after about 20 years and was pleased to find that hardly anything had changed. The only things missing were the dove in the birdcage and the old lacemaker herself, who sadly passed away in 2001. However, when I started painting, I was approached by her daughter, who remembered me. I had forgotten that I had sent them a catalogue, which contained several images of her late mother in the paintings – it obviously struck a chord.

Demonstration: Red Table and Jugs

Introduction

As I have mentioned already the many objects in my studio are constantly moved around, as is the furniture, and this can sometimes lead to an exciting accidental arrangement, one that stirs me to make something of it. In this case I liked the busyness of this still life, which suddenly appeared with some red objects on a red table contrasted with the white sails of the toy yacht and black hull of the Clyde puffer. It was painted under artificial light creating strong shadows.

Materials

- Watercolours: alizarin crimson, cadmium scarlet, cadmium yellow, lemon yellow, cerulean blue, yellow ochre, Payne's grey.
- Oil pastels: white, grey, red, orange, yellow.
- Berol Karismacolor water-soluble pencil.
- Waterford NOT 300 gsm paper, 53 x 71 cm (21 x 28 in.).

Stage 1

I started by using a white oil pastel to draw in a few of the main shapes: the circular lantern reflector, the owl's head, the Jacob's sheep's skull and the white background cloth. I then used a large mop brush to lay in very wet 'puddles' of colour, not worrying too much at this stage if the colours ran into each other.

Stage 2

When the paper had dried a little but was still damp I quickly drew into the coloured washes, trying to keep spontaneity and life in the painting. I was trying to keep the shapes of the objects as accurate as possible but not be overly concerned with any inaccuracies. It was more important to me that there was a flow to the work rather than an analytically correct drawing.

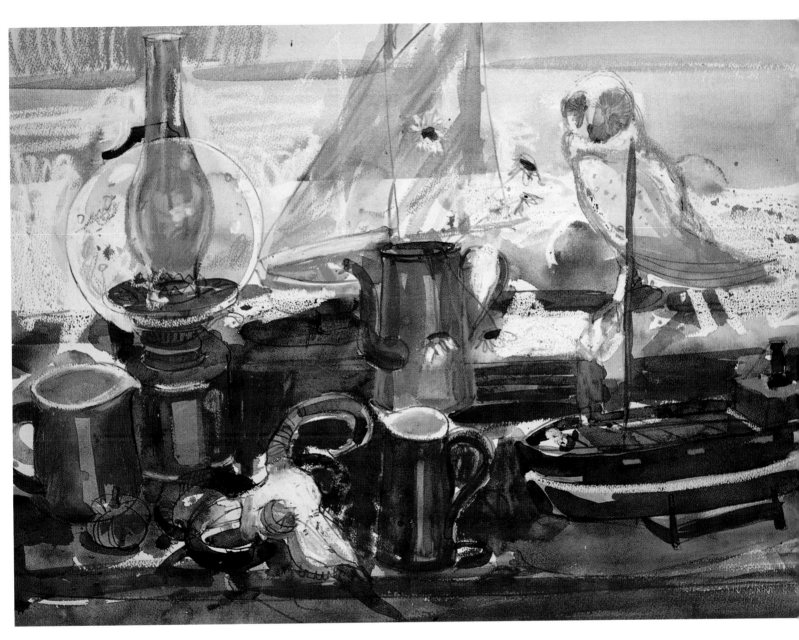

Stage 3

Finally I worked into the whole painting with stronger washes and a more pigment-laden brush. I also drew into some of the objects with a white and grey oil pastel to try and make them more solid-looking. In this painting I have attempted to keep the painting spontaneous and achieve a balance between line and colour throughout.

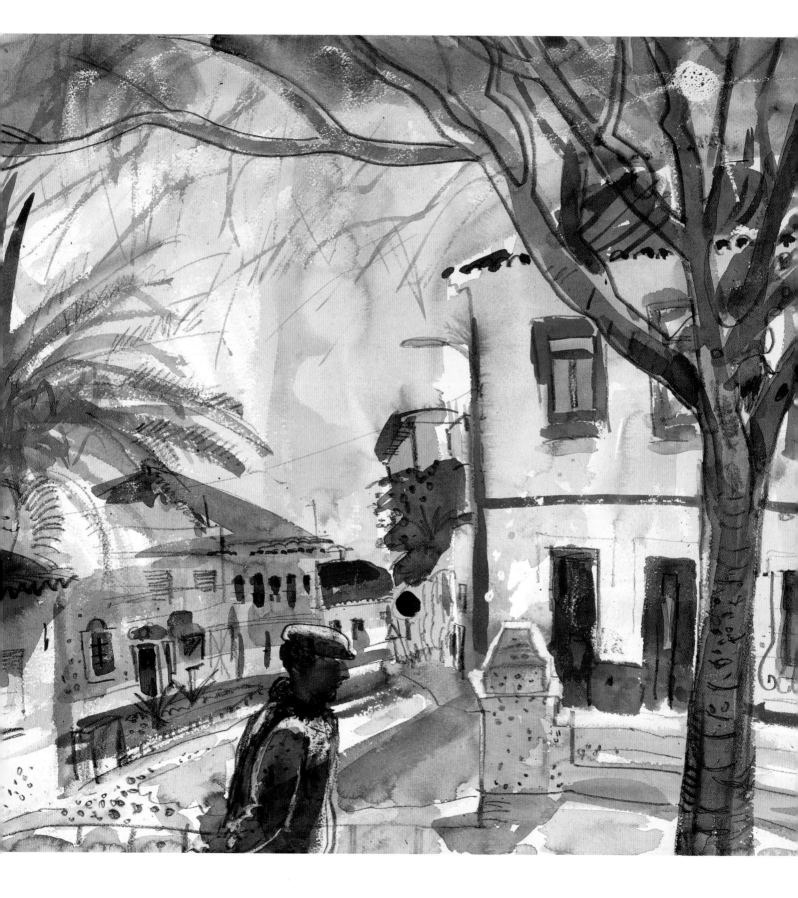

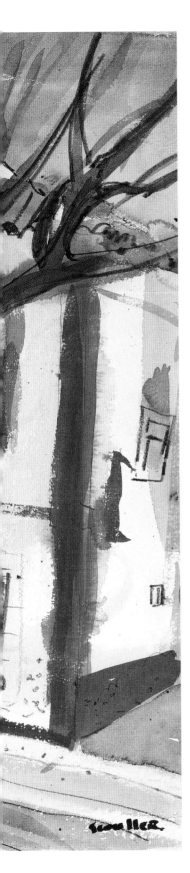

Winter's Day Stroll, Algarve, Portugal

Watercolour, Berol Karismacolor water-soluble pencil, oil pastels, Saunders
Waterford 300 gsm NOT paper 53 x 71 cm (21 x 28 in.) Private collection
My intention for this painting was to have the tree, with winter sun filtering
through its bare branches, as the main subject of the picture. Having finished
it, I wasn't all that pleased with the end result – it lacked something. There
were a few people milling about, one of whom started walking my way.
Unbeknown to him, he became the missing ingredient that provided a little bit
of extra interest to the finished work.

Evening Glow, Montesquieu-des-Albères, France

Watercolour, Berol Karismacolor water-soluble pencil, oil pastels, Saunders
Waterford 300 gsm NOT paper 53 x 71 cm (21 x 28 in.) Private collection
Here, I enjoyed trying to capture the subtle colour just before dusk as the light
starts to fade. By the time I had finished it, the light was well and truly gone.

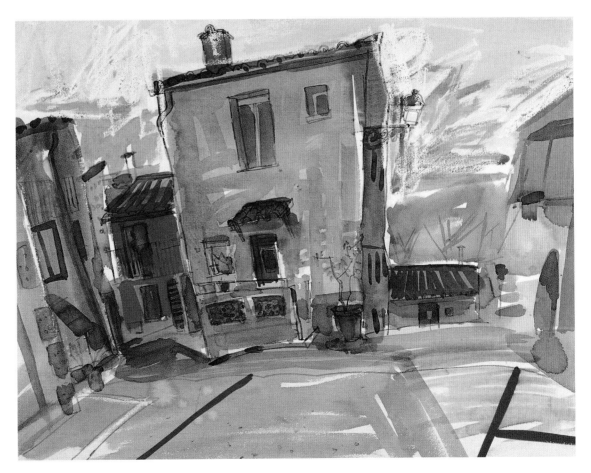

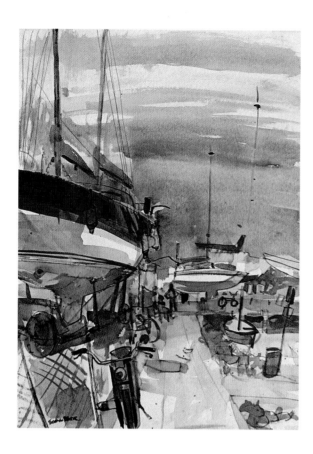

Yachts and Moped, Antibes, France

Watercolour, Berol Karismacolor water-soluble pencil, oil pastels, Saunders Waterford 300 gsm NOT paper 71 x 53 cm (28 x 21 in.) Private collection
When you think of a landscape, you immediately think of a shape that is rectangular and horizontal, but it's worth considering which other orientation could be used to make an interesting picture. Here the vertical shapes of the boat's masts suggested to me that taking the paper vertically would make a much more pleasing and dynamic arrangement.

Old Quinta, Almancil, Algarve, Portugal

Watercolour, Berol Karismacolor water-soluble pencil, oil pastels, Saunders Waterford 300 gsm NOT paper 71 x 53 cm (28 x 21 in.) Collection of the artist
I decided to tackle this old building on the outskirts of Almancil face-on, with virtually no perspective apart from the side of the overly large chimney and the elevation banding at either end of the building. Another problem was the tonal value of the walls, which was almost the same as the value of the sky, so I decided to exaggerate and darken the building at the top in order to make it stand out against the sky. I enjoyed the simplicity of what I saw, interspersed with the clutter of daily life lying around the front yard.

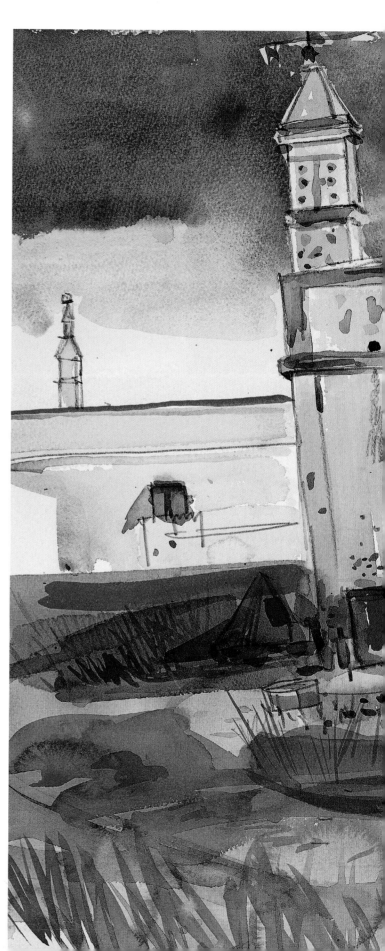

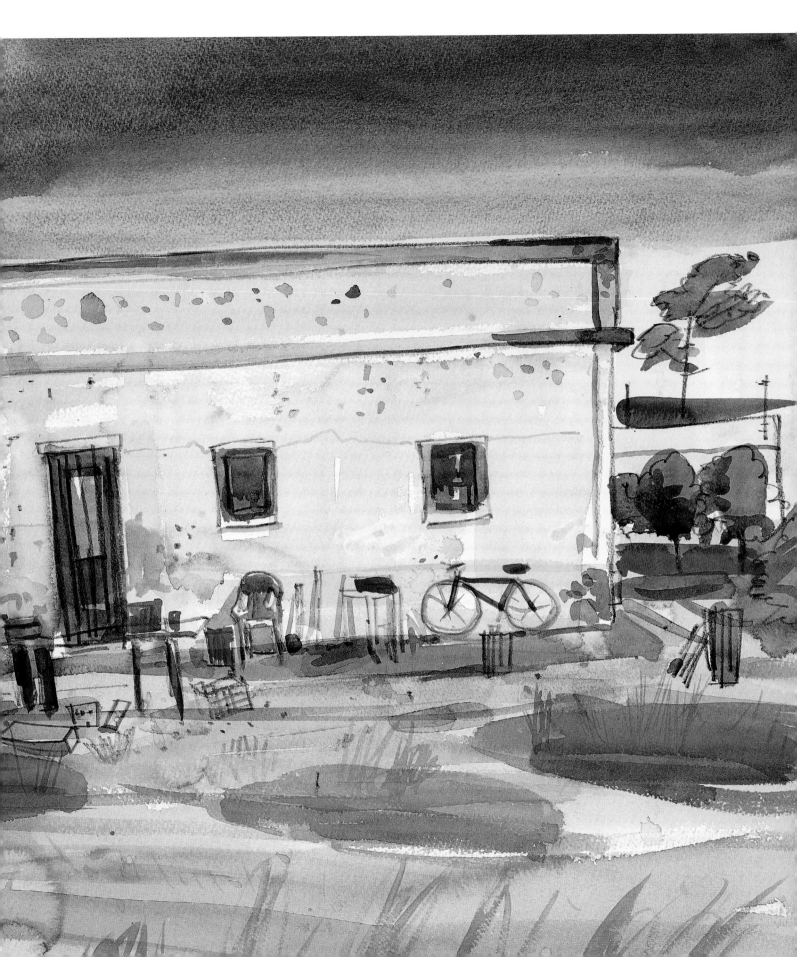

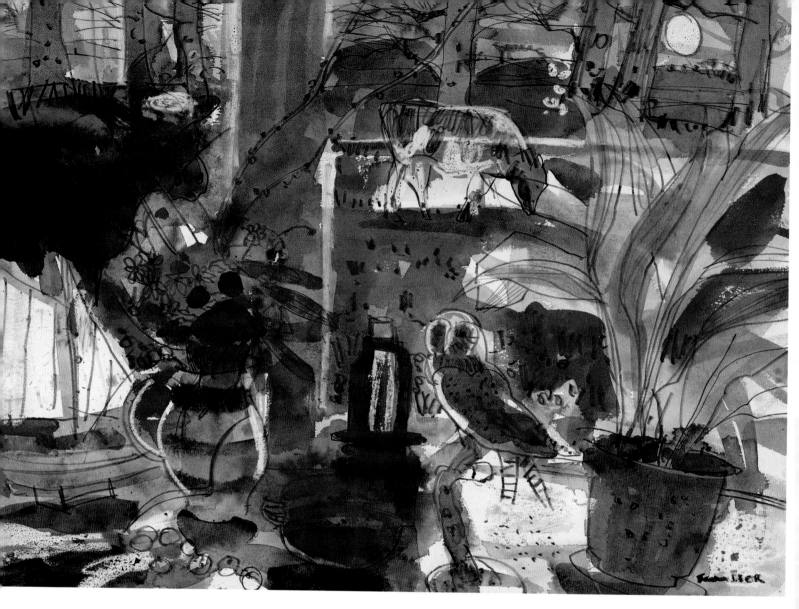

Windows

Windows have always fascinated me. At school I was often getting into trouble for staring out of the classroom window. I guess I was always a bit of a dreamer, looking out and wanting to be somewhere else – in those days that would have been either in the art room or on the playing field doing sport, the only two things I excelled in.

In later years, when I was myself a secondary school teacher, I used to do lots of drawings of the pupils posing in front of the classroom windows, or I would use the windows as a backdrop for the children to paint a still life. Yet I would still gaze out of the window and wish I were somewhere else, able to paint full-time. Happily, after some fifteen years of teaching art, I was very fortunate to be selling enough work to enable me to achieve this.

Still Life: Cows and Window

Watercolour, Berol Karismacolor water-soluble pencil, oil pastels, Saunders Waterford 300 gsm NOT paper 53 x 71 cm (21 x 28 in.) Private collection

I thought this made an unusual subject and it was a different take on my usual window paintings. It was done from the studio window of a rented farmhouse we were staying in; there were lots of interesting vistas and trees surrounding the property. I had painted and drawn the cows many times before when outside, but set up this still life in the hope that they would wander near my window – and fortunately one of them did.

Kitchen Window

Rotring Rapid PRO 2.0 clutch pencil with 4B lead, Green and Stone sketchbook 30 x 43 cm (12 x 17 in.) Collection of the artist

This rapid pencil drawing was done with a view to making a larger watercolour. It's helpful, sometimes, to work out ideas for a composition in a sketchbook before tackling something on a larger scale. It's something I do, but not all the time. There are days when I want to get straight

into the paint and be really bold, and there are times when that approach is not hugely successful so I will revert to a sketchbook and scribble down a few more ideas.

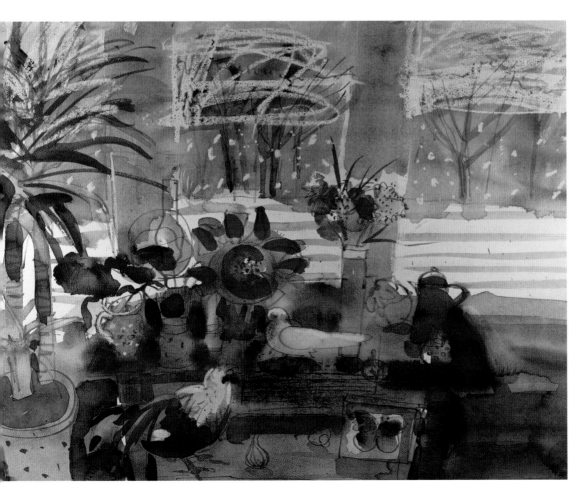

Winter Still Life

Watercolour, Berol Karismacolor water-soluble pencil, oil pastels, Saunders Waterford 300 gsm NOT paper 53 x 71 cm (21 x 28 in.) Private collection

One very cold winter's afternoon, just a few days before Christmas, I painted this still life. It was a real blizzard outside and from the comfort of my studio, I tried to convey that feeling by using cool values of blue and grey. The chilly scene contrasted with the assortment of objects scattered almost haphazardly on the table and floor, which were depicted with mainly warm values of red, purple and yellow inside the relatively warm studio. We made the image into a Christmas card the following year.

Figures

I enjoy painting figures as a means of adding human interest to a painting. In fact, all of my landscapes generally reveal the mark left by man, be it a building, telegraph pole, road, garden or whatever – there is usually evidence of man there somewhere. I also enjoy the challenge of trying to capture the essence of a passing figure who might just 'make' a painting, trying to memorize the image and bang it in quickly before it fades.

Accordion Player, Florence, Italy

Fibre-tip pen, Moleskine sketchbook 22 x 13 cm (8½ x 5 in.) Collection of the artist
This is just a quick doodle, really, but the accordion player made an interesting subject and the opportunity to have a bash at drawing him was too good to miss. I could probably have spent a long time drawing this street musician with a more analytical eye but Florence is such an amazing city you expect to find something even more exciting to draw around the next corner.

Lacemaker, Dove and Cat, Falacho, Algarve, Portugal

Watercolour, Berol Karismacolor water-soluble pencil, oil pastels, Saunders Waterford 300 gsm NOT paper 53 x 71 cm (21 x 28 in.) Private collection
This was the first painting of many I did over several days of an elderly lady, dressed in mourning black, who was quietly making lace. It is probably my favourite of them all. Perhaps it's because the memory of how excited I first was to find this place is still fresh in my mind. The figure and creatures are positioned at the very edge of the composition, where their unusual placing is balanced by other objects, including the tree inserted on the Golden Section and the red splash of the letterbox.

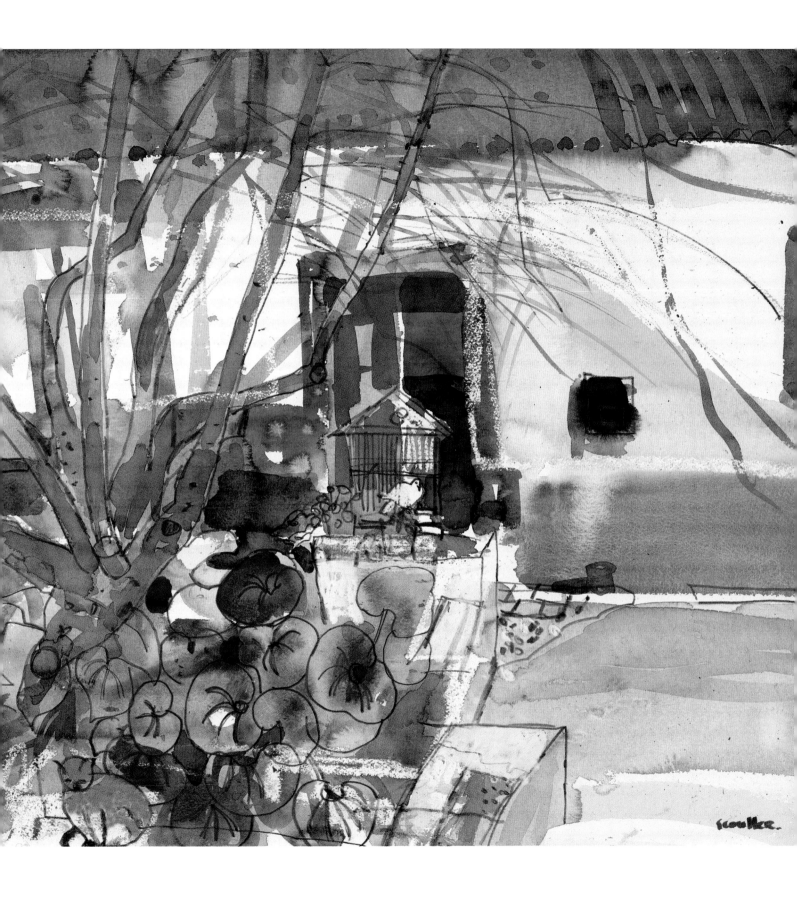

Boy Fishing, Cros-de-Cagnes, France

Watercolour, Berol Karismacolor water-soluble pencil, oil pastels, Saunders Waterford 300 gsm NOT paper
53 x 71 cm (21 x 28 in.) Private collection

This was painted before the old port was tidied up and modernized, no doubt as a result of EEC money and much to my disappointment (but I'm sure to the delight of the fishermen who ply their trade there every day). The scene had all the ingredients I enjoy painting – colour, clutter, a figure and light. It is not the same place today, although it still retains a certain amount of its old charm.

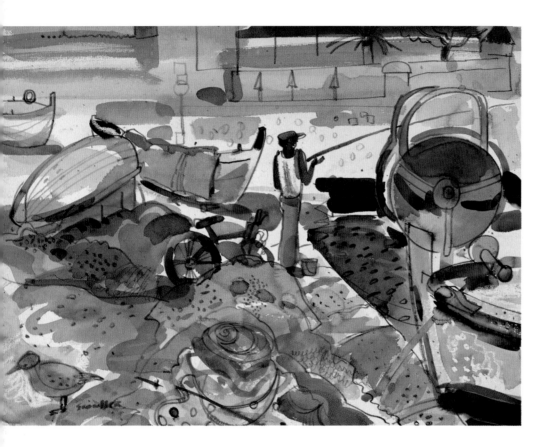

Boy on Train to Bologna, Italy

Fibre-tip pen, Moleskine sketchbook 22 x 13 cm (8½ x 5 in.)
Collection of the artist

This work is from the same little sketchbook as *Accordion Player* (page 96), which I managed to fill over the course of two days. The line drawing was made in a crowded train carriage en route from Florence to Bologna. The young teenager was too wrapped up in his music to notice I was drawing and scrutinizing him.

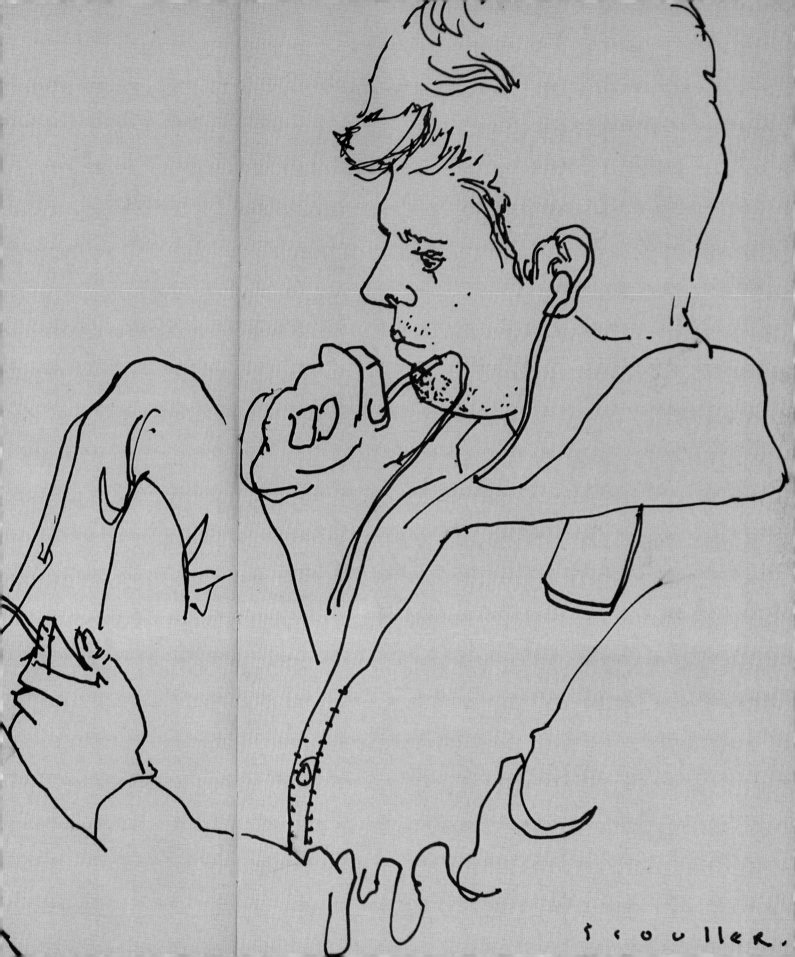

Animals

I'm not sure where my fascination with drawing animals comes from. More than likely, it was inspired by the drawings of Henri Gaudier-Brzeska (1891–1915), which I find beautiful in their economic use of line. Animals are also just great things to draw: they are often curious, full of life, and within a zoo setting it is possible to get up close to something you wouldn't dream of going near in the wild. I have also had a stab at drawing wild animals in South Africa, but found it difficult to get near the creatures I wanted to draw. Without the aid of a spotting scope or the use of photographs (which I'm sure many wildlife artists resort to), it is tricky.

Chimp, Edinburgh Zoo

Watercolour, Berol Karismacolor water-soluble pencil, John Purcell sketchbook with 300 gsm HP paper 28 x 24 cm (11 x 9 in.) Private collection
As I recall, I only used one colour – burnt umber – for this little fellow, who sat obligingly just a few feet away from me while scratching and doing his habitual de-lousing act. By using varying amounts of water in the wash, I tried to show the light and dark areas of the subject before he moved off to practise his routine on one of his peers.

Feeding Time, Edinburgh Zoo

Compressed charcoal, Green and Stone sketchbook 22 x 30 cm (8½ x 12 in.)
Collection of the artist
The midday penguin parade at the zoo is always popular with the visiting public and I felt I should do something based on this event. I made a number of studies of the keepers as they were feeding and keeping an eye on their charges – it is not unheard of for penguins to try to make a dash for freedom. From the various studies I made on site, I managed to paint a few small oils of this daily activity.

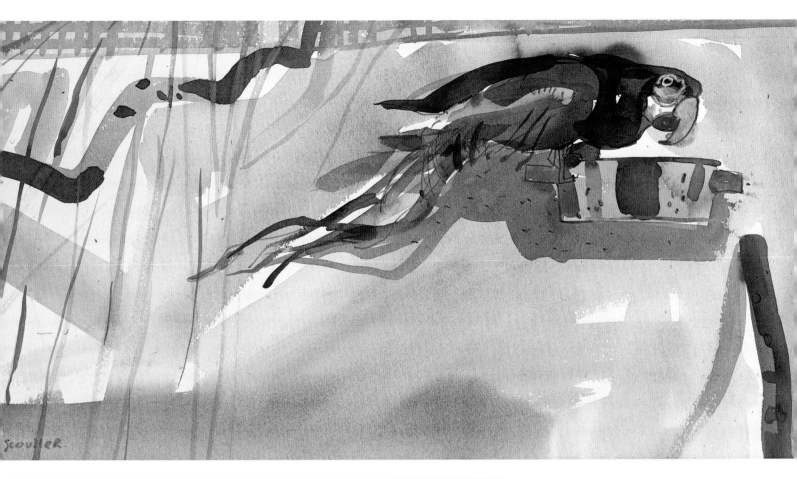

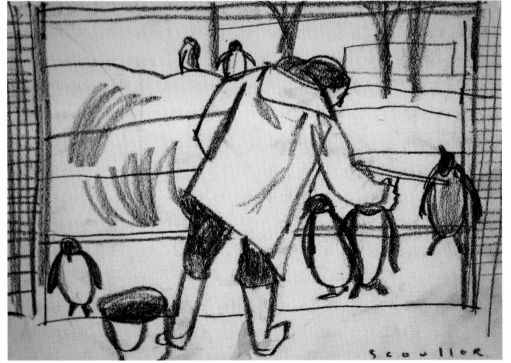

Red Macau, Edinburgh Zoo

*Watercolour, Berol Karismacolor water-soluble pencil,
oil pastels, Saunders Waterford 300 gsm NOT paper
30 x 60 cm (12 x 24 in.) Private collection*

During a six-month period I spent in Edinburgh
Zoo, I produced a fair number of drawings and
watercolours for a solo show at the Open Eye
Gallery in Edinburgh. Apart from the cold Scottish
winter days it was a really enjoyable experience,
as I have always taken delight in drawing and
studying animals. The show, however, was not
about trying to do analytical, anatomically
correct studies of my chosen subject, but more of
a statement about them and their surroundings
within the zoo. I have drawn a red macau
in London Zoo as well, attracted to it by its
magnificently coloured plumage.

Plane Trees, Collioure, France

Fibre-tip pen, Moleskine sketchbook 22 x 13 cm (8½ x 5 in.) Collection of the artist
A quick doodle done in the marketplace in Collioure. I used hatching lines to show the areas of the huge plane trees that were in shadow. The whole thing is very active and spontaneous; it was not meant to be a finished drawing – it was just done as a note, which could perhaps be used in a future painting.

Farms and villages

Farms and farmyards are a subject that I enjoy painting, as they are generally untidy places with lots of interesting things lying around, including machinery and tools, and of course there are animals. They are usually a hive of activity, with people milking cows, feeding hens or other animals, mucking out byres, or working on machinery. These are all interesting subjects for drawing or paintings.

The Hen Run, Churchhaven, Western Cape, South Africa

Watercolour, Berol Karismacolor water-soluble pencil, oil pastels, Fabriano Artistico 300 gsm NOT paper 53 x 71 cm (21 x 28 in.) Collection of the artist

This is basically an L-shaped composition – if you can visualize the 'L' lying on its side and upside down! I tried to balance the large, empty space of the left foreground with the busy area of the buildings, hens and trees around the fringes of the painting. Dry brushstrokes on the 'rough' surface of this paper helped to convey the weather-beaten surface of the chicken coop's wooden structure.

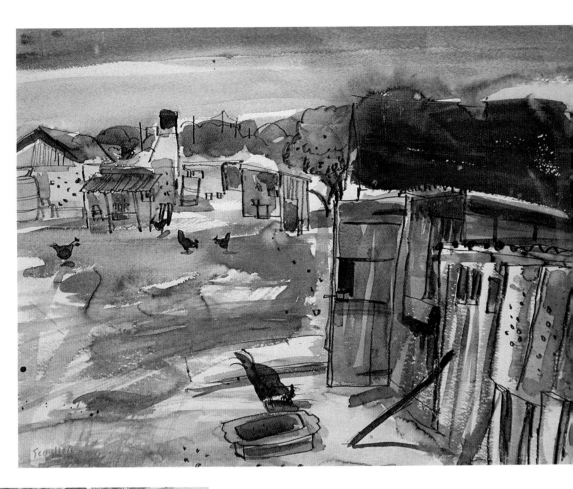

Hens, Village Farm, Bordeira, Algarve, Portugal

Watercolour, Berol Karismacolor water-soluble pencil, oil pastels, Saunders Waterford 300 gsm NOT paper 53 x 71 cm (21 x 28 in.) Private collection

A great subject for me to draw, this farm was full of life, activity and clutter. I started by roughing in areas of bright sky with a white oil pastel. I then laid in the main shadow areas with pale ultramarine washes, continuing when they were dry with pale washes over the other main features of the painting – trees, foliage, buildings etc. Next, I started to draw into it with a pencil. Finally, I strengthened the shadow colour and other areas where I felt this was necessary.

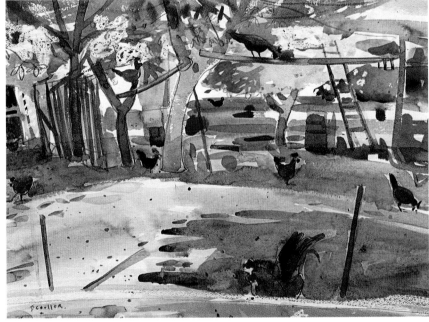

Villages and their surroundings are a subject that I have kept going back to, ever since the days of my art school travelling scholarship to Crete, where I spent two months on the mountain plateau of Lasithi. This fascinating place could only be reached by a precipitous twisting road through rugged terrain, which eventually led you to an unexpectedly fertile plateau dotted with white-sailed windmills (wind-powered pumps) used to irrigate the soil. At one time, there were over 10,000 of these, but their numbers have dwindled over the years. They still present a magnificent sight as you go through the mountain pass and on to the green plateau; back then, they certainly made a big impression on this young art student.

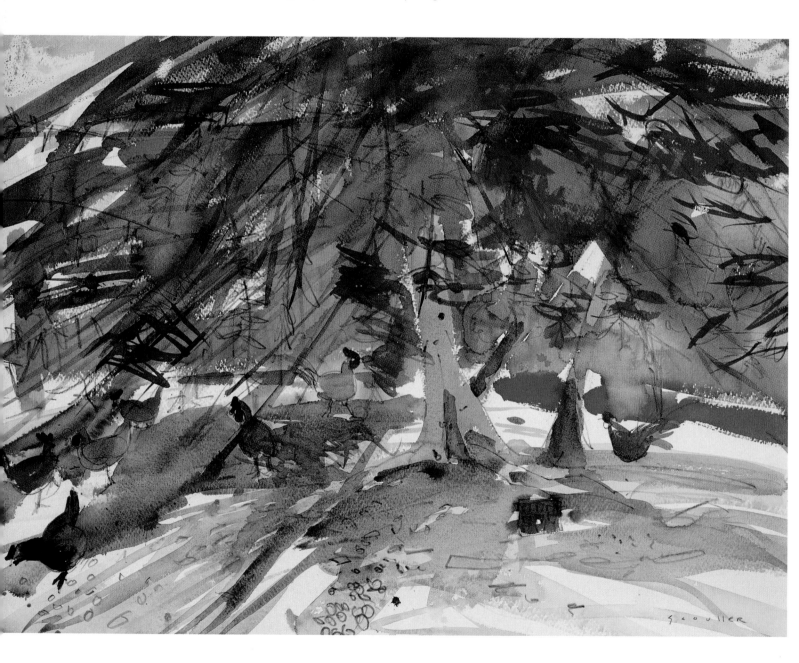

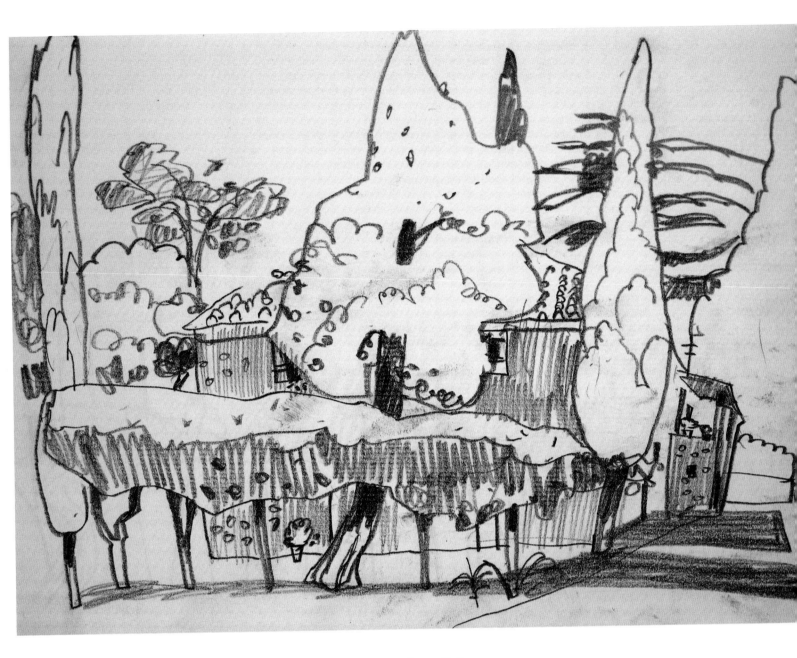

Farm and Hens, Falacho, Algarve, Portugal

Watercolour, Berol Karismacolor water-soluble pencil, oil pastels,
Saunders Waterford 300 gsm Rough paper 53 x 71 cm (21 x 28 in.)
Collection of the artist

Here I was trying to convey the feeling of strong sunlight streaming through the trees as the hens foraged in the shade for food. The leafy glade provided them and me with a respite from the intense sun. I painted *contre-jour* in the late afternoon sunshine; this was another great find at the end of a dusty cul-de-sac.

Farm, Sicily

Staedtler clutch pencil with 4B lead, Daler-Rowney sketchbook 30 x 22 cm
(12 x 8½ in.) Collection of the artist

It was the shapes of the different trees and shrubs on this Sicilian farm that attracted me. They looked as if they had all been carefully coiffured by one of the local barbers and had a very surreal quality about them; they resembled the green foam that florists use in their arrangements rather than closely cut foliage. The farm itself was almost hidden amongst the topiary-shaped hedges and trees. My idea at the time was to produce a painting later in my studio … that one is still waiting to happen!

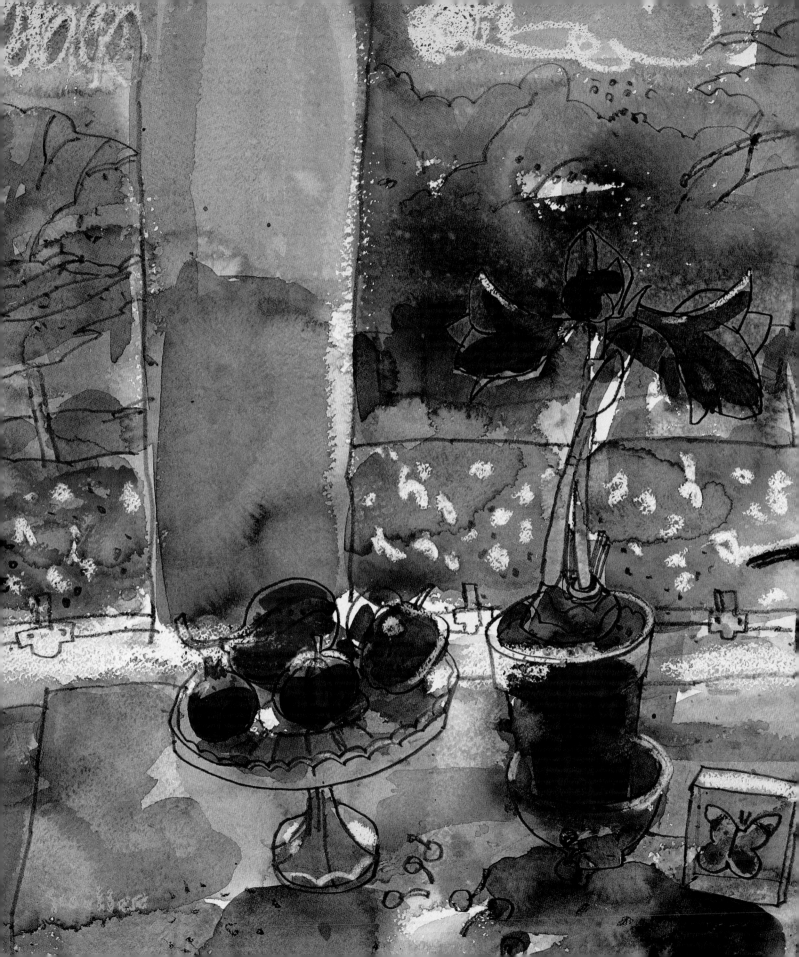

Working in the studio

Today I drifted with Camille on the Seine at Argenteuil. The views materialized and dissolved and I was as contented as a cow in her stall.

Claude Monet (1840–1926)

Working in a studio environment can afford the artist more time to reflect on his or her work, to make works on a grander scale, and to set up still life and portrait situations not possible in the ever-changing light and weather conditions of *plein-air* painting. The studio can also be a place for experimenting with materials before putting any newfound knowledge into practice in front of a landscape.

The Dutch Amaryllis

Watercolour, Berol Karismacolor water-soluble pencil, oil pastels, Saunders Waterford 300 gsm NOT paper 53 x 71 cm (21 x 28 in.) Private collection
The hues of early spring provided the backdrop for this still life. The painting is really about my love of colour; the warmth of the yellows and reds acts as a unifying force throughout. I added a few crucial bits of detail in the objects on the table to help separate them from the background and bring them closer to the viewer.

Farm Window

Watercolour, Berol Karismacolor water-soluble pencil, oil pastels, Saunders Waterford 300 gsm NOT paper 53 x 71 cm (21 x 28 in.) Private collection
I felt there was enough happening here to keep the eye interested throughout, so this time there was no need for cattle in the middle distance. My active, staccato pencil marks link background and foreground.

However, a studio also has drawbacks. It can be too comfortable and a place where the artist slips into bad habits, producing work after work with no new ideas being introduced from external sources. Work can also become laboured and lack spontaneity. That is why experiencing subjects at first hand and using a sketchbook is important for artists who prefer the comfort of the studio for producing finished works. I am often surprised by the number of times I have used a few squiggly lines from a sketchbook as the inspiration for a larger scale painting in the studio.

Personally, I would rather work directly from life, but I also do enjoy working from drawings and studies made *in situ*. In fact, for me working from drawings would always be preferable to slavishly copying from a photograph, as opposed to a 'lively' drawing which contains all the important elements of my chosen subject.'

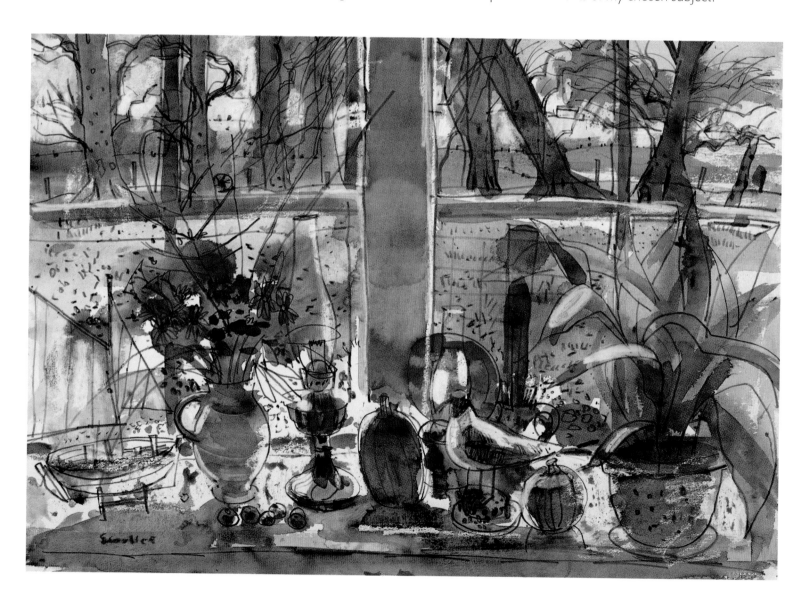

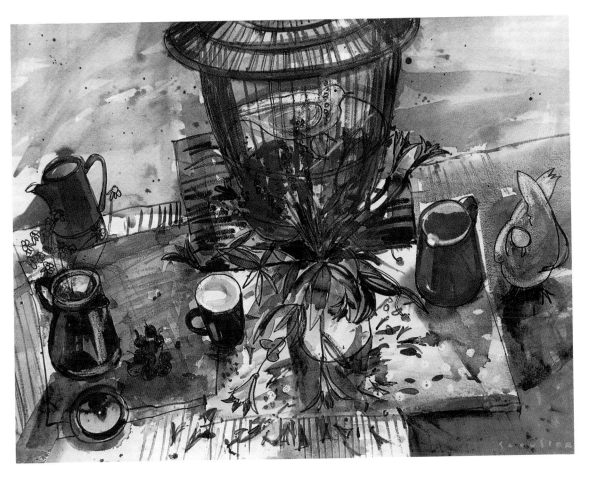

Strawberries and Summer Bouquet

Watercolour, Berol Karismacolor water-soluble pencil, oil pastels, Saunders Waterford 300 gsm NOT paper 53 x 71 cm (21 x 28 in.) Collection of the artist

Inspired by a bouquet of flowers my wife Carol had picked from the garden, I made it the centrepiece of this still life, placing it against the light on the studio floor. I wanted the painting to be full of colour and flooded with summer light. The painting's main colour element is basically the three primary colours – red, blue and yellow – used with differing dilutions of water, plus viridian, and finished with judicious touches of white, pink and grey oil pastel here and there.

In a sense, a photograph gives you too much information and doesn't edit the scene, whereas in a sketch or drawing, you edit by only including what's really important. A few scribbled lines can be very informative and speak volumes more than a photograph. Of course that is not to say that a photograph is not a useful tool in the artist's armoury: it is just not my first or preferred port of call. For example, about 15 years ago I was commissioned to paint some 20 large oil paintings for a Glasgow restaurant. The new restaurant was to have a 'fusion' style of food, so they sent me to Singapore and Borneo to garner ideas. Because of the logistics involved, I felt a camera would be a useful addition to my sketchbooks – and so it proved.

As a general rule, when I do a watercolour (large or small, either in the studio or *en plein air*), it usually begins with a bluster of activity and progresses to a calmer finish. Initially I tend to work very loosely, using large brushes with great puddles of colour, enjoying the freedom of making large, almost abstract areas of colour. At this stage it can look just that – like an abstract painting – but then I gradually refine it using pencils, oil pastels and smaller brushes with a more feathery touch, until I have taken it as far as I feel necessary.

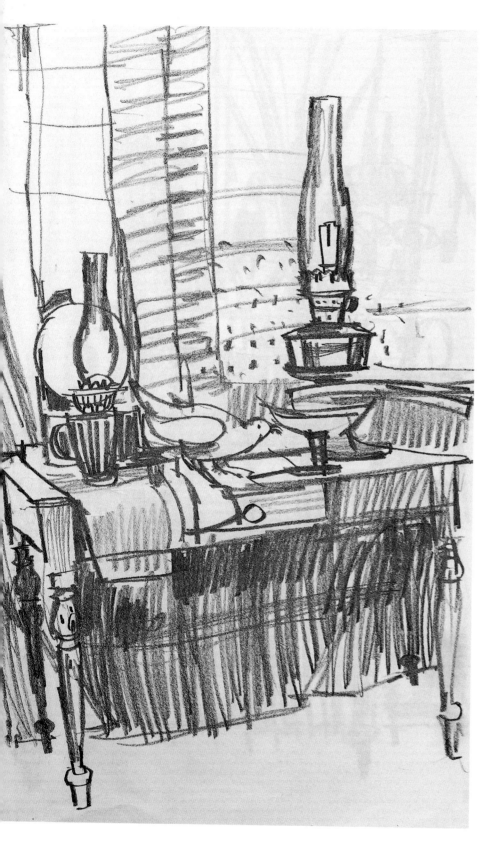

Still life

For me the studio is a place for contemplating, assessing and reflecting upon ongoing work and ideas. With regard to still life, it is a space where new ideas and problems are created and hopefully resolved, and a subject with which the artist can experiment to his heart's content in the relative calm of his workplace.

Although I find it exciting stumbling upon an accidental still life, say in a kitchen or bedroom or wherever, it is just as exciting, although more contrived, to 'set up' a still life group within the more controlled environment of the studio. In traditional terms a still life usually means an arrangement of all kinds of man-made or natural objects, flowers, fruit, fish, wine etc. If the artist uses objects and materials that have a personal significance or visually excite him or her then chances are that expression of excitement will be transferred into the work produced.

Tabletop and Lanterns
Rotring Rapid PRO clutch pencil with 4B lead, Roberson Bushey sketchbook 51 x 35 cm (20 x 14 in.) Collection of the artist.
I enjoy the large size of this book, which is useful for making big, expressive drawings or studies before finalizing a design for a painting. I also like using a clutch pencil, as I hate having to pause to sharpen pencils, in effect stopping my flow of work. With the clutch pencil all I have to do is move it around to get a thick or a thin line, and with a simple click I have more lead.

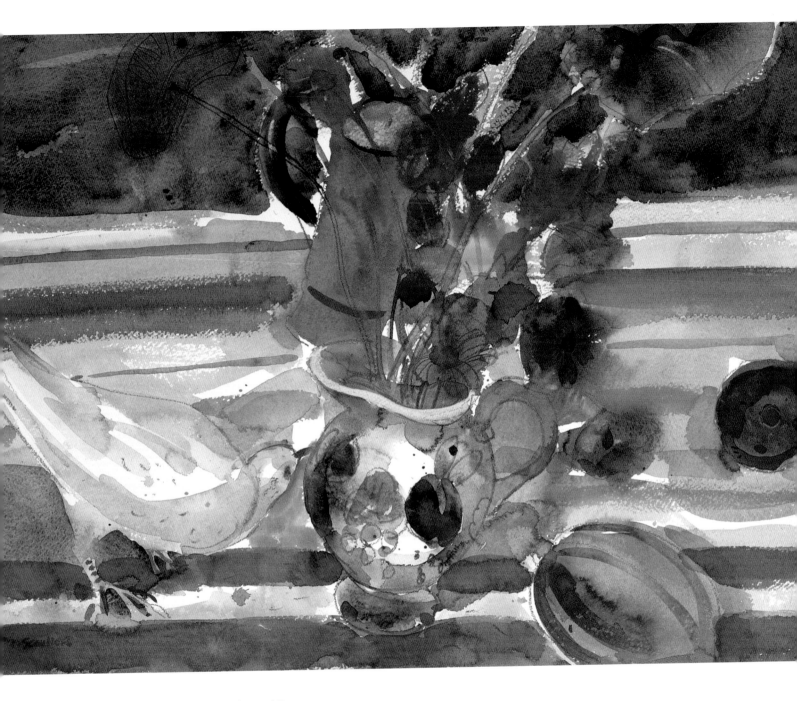

Poppies and Dove

Watercolour, Berol Karismacolor water-soluble pencil, oil pastels, Saunders Waterford 300 gsm
NOT paper 53 x 71 cm (21 x 28 in.) Private collection

Bold horizontal stripes and an equally bold placing of objects in the middle of the composition made this an unusual still life group. The spongeware jug has featured in many of my paintings over the years. It's strange how certain objects recur almost obsessively in paintings until suddenly they are discarded, only to pop up again years down the line. In a sense, this reaffirms that the object was a good purchase when you first saw and fell in love with it in the junk shop, market or wherever!

Two Birdcages

Watercolour, Berol Karismacolor water-soluble pencil, oil pastels, Arches Rives paper 92 x 102 cm (36 x 40 in.) Private collection

Again, I'm taking a chance with composition by placing most of the foreground interest way off-centre, to the left, but balancing it with careful placement of the background objects. There is also a strong diagonal in this painting, running from the bottom left corner to the top right corner: this also leads your eye from front to back. I find painting at this size really enjoyable, but also a technical challenge as I always paint watercolours with the paper completely flat, so it makes working at the top of the paper a bit of a struggle.

Owl and Gourds

Watercolour, Berol Karismacolor water-soluble pencil, oil pastels, Saunders Waterford 300 gsm NOT paper 53 x 71 cm (21 x 28 in.) Private collection

Placing an object smack in the middle of a painting instead of using the traditional Golden Section is always a bit of a gamble, but I enjoy taking a risk with composition. It can either be a total disaster or make for a very dynamic composition.

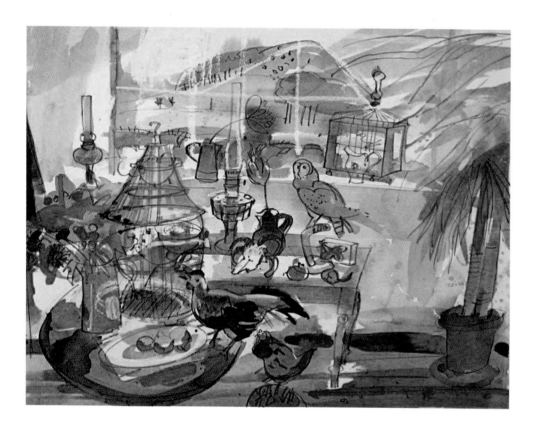

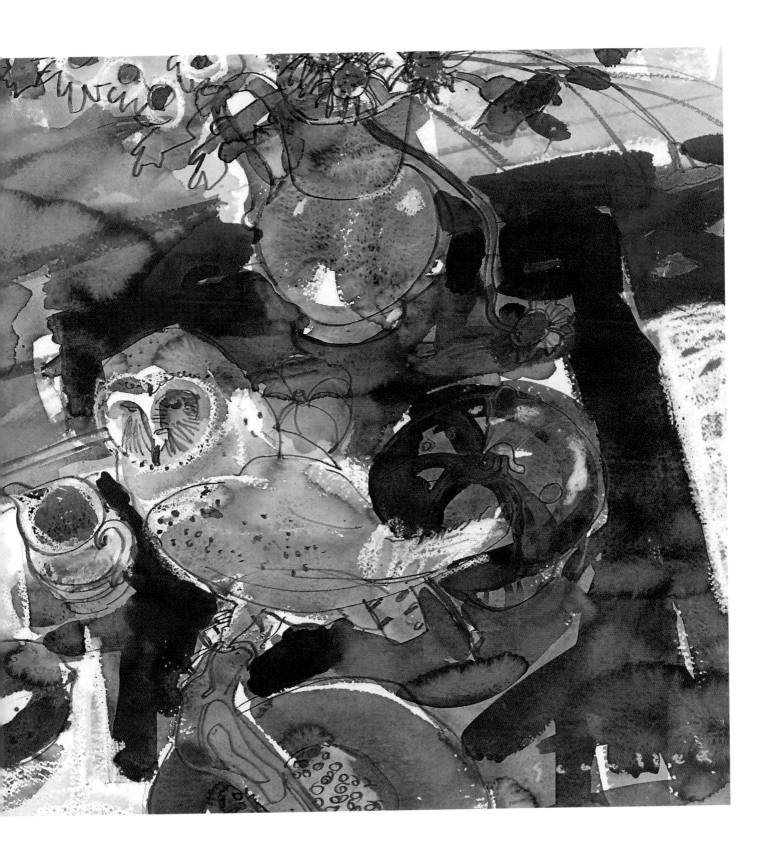

Portraits

I could never see myself fitting comfortably into the niche of 'society' portrait painter, much preferring to do studies of my family and friends, and also informal portraits of people on my travels – usually farmers or people at work.

Carol Lounging

Fibre-tip pen, Moleskine sketchbook 22 x 13 cm (8½ x 5 in.) Collection of the artist

A quick line drawing of my wife, made when she was about to nod off.

Jim, Fast Asleep

Conté pencil on grey paper 38 x 55 cm (15 x 22 in.) Collection of the artist

This was a drawing I made almost exactly 40 years ago, about a year after leaving art school. It shows my early interest in line drawing. The late Shetland poet and potter Jim Moncrieffe was my subject, fast asleep in front of his cottage fire.

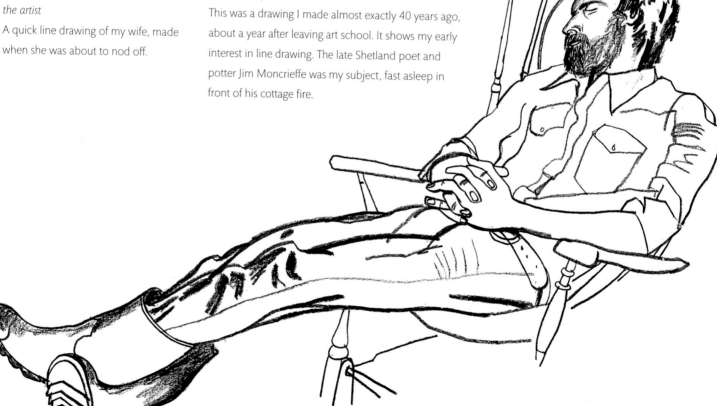

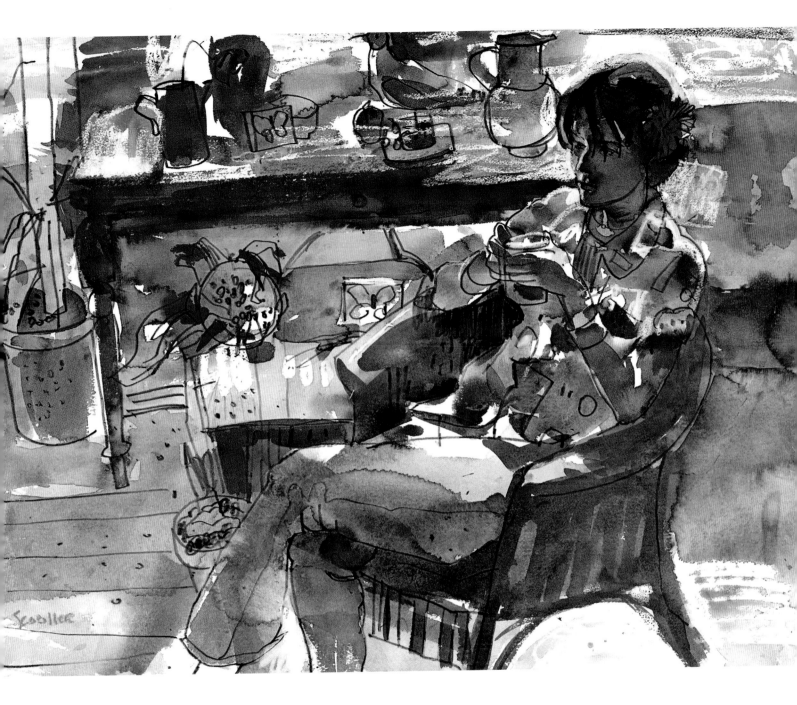

Kim

Watercolour, Berol Karismacolor water-soluble pencil, oil pastels, Waterford 300 gsm NOT paper 53 x 71 cm (21 x 28 in.) Collection of the artist

This is a painting of my eldest daughter, Kim, done about 16 years ago during the summer holidays before she started at art school. She was wearing a very colourful blouse that day and had stuck a garden flower behind one ear: it was too good a subject to let go. After a bit of persuasion, I positioned her beside a table against my studio window. The usual studio clutter from dismantled still lifes was lying around and I decided to include some of it in my painting.

The whole painting was completed in about an hour, painted and drawn rapidly to try to capture the dappled light hitting the figure, table and objects. The colours I used were permanent magenta, ultramarine, emerald green, cadmium yellow, bright red and Payne's grey. I first used a white Caran d'Ache oil pastel to lay in where I thought the light areas would be, and then I rapidly introduced large areas of mid-tones. While everything was still wet, I drew into the whole composition, taking extra care to get the head of the figure just right.

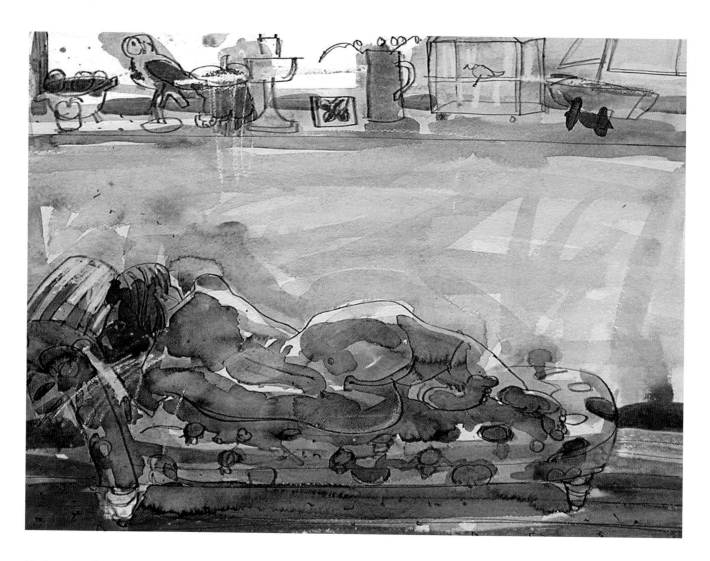

Nude on Daybed

*Watercolour, Berol Karismacolor water-soluble
pencil, oil pastels, Saunders Waterford 300 gsm
NOT paper 53 x 71 cm (21 x 28 in.) Collection
of the artist*

Another favourite model over the years has
been my wife, Carol. Here she is seen fast asleep
– after all, posing is tiring work – on a daybed
under the studio window. The windowsill was
adorned with a line of objects to help balance
the composition.

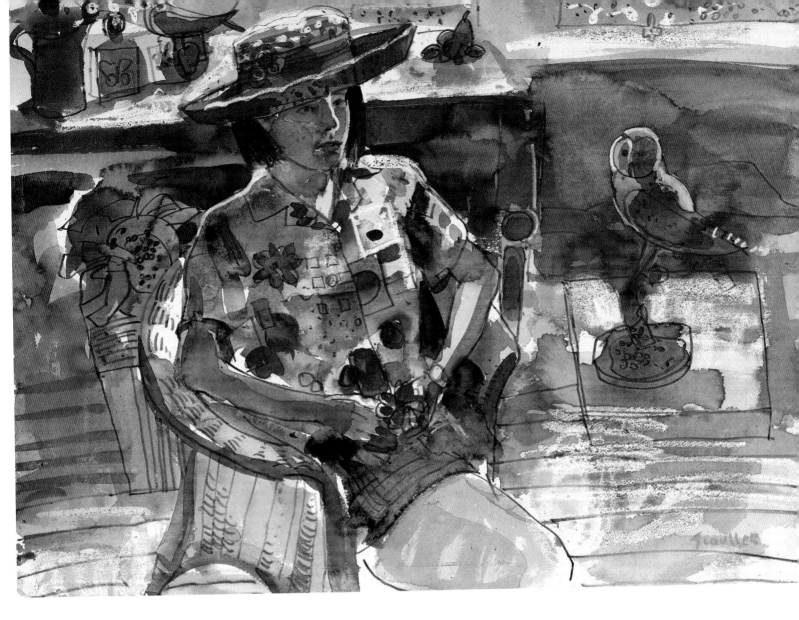

Kim and Lara Sunbathing

Cretacolor clutch pencil with 6B lead, Roberson
Bushey sketchbook 35 x 50 cm (14 x 20 in.) Collection
of the artist

This was drawn on one of our painting expeditions
abroad, when the kids were young and when we
travelled in our caravan. Having a caravan as a mobile
studio is great and very flexible: when you get fed up
with a location, you can up sticks and move somewhere
else. The girls were relaxing after a hard day at the pool
and made good, unsuspecting models... they were too
exhausted to move!

Lara

Watercolour, Berol Karismacolor water-soluble pencil, oil
pastels, Saunders Waterford 300 gsm NOT paper 53 x 71 cm
(21 x 28 in.) Collection of the artist

Shortly after completing the painting of Kim I managed to
persuade Lara, her younger sister, to pose for me. Again, I
had seen Lara wearing a nicely patterned blouse, which she
obligingly wore as she posed for me. She put on one of my
straw hats to complete the look.

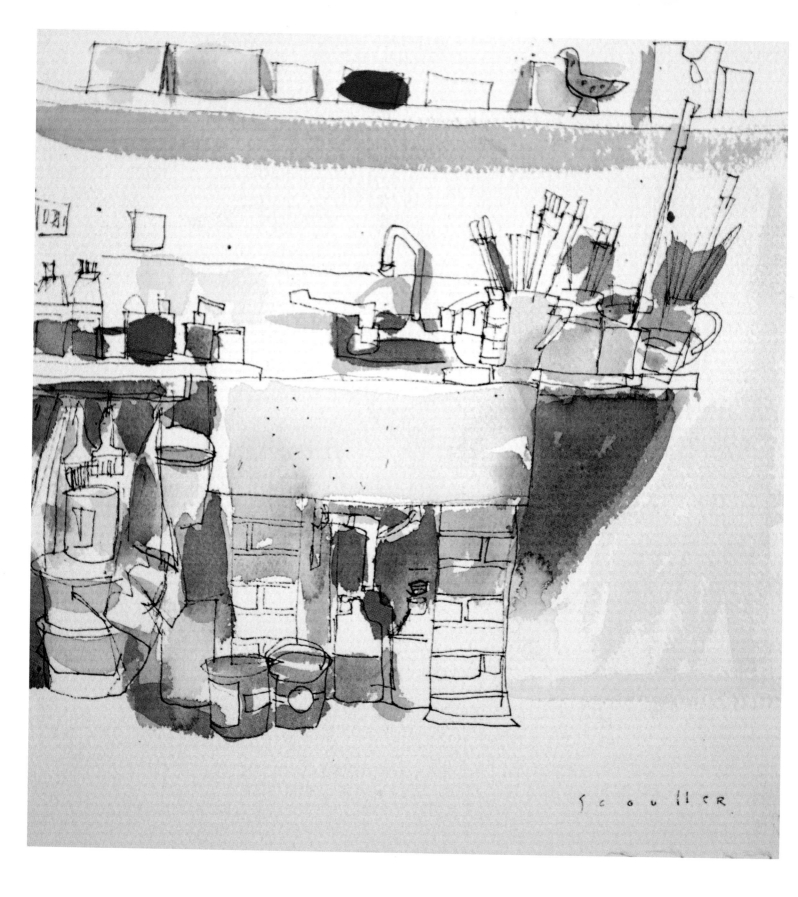

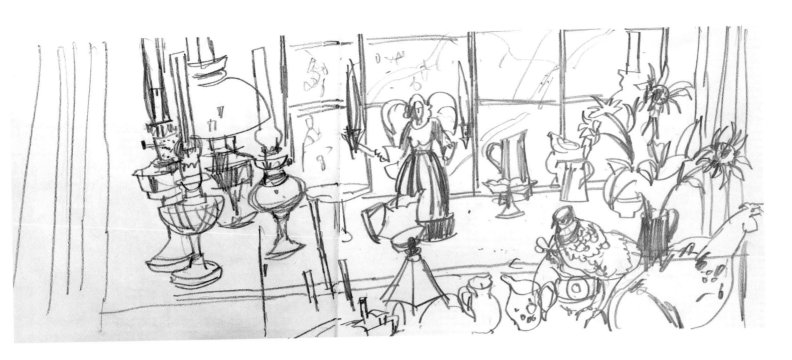

Studio Sink

Watercolour, fibre-tip pen, Roberson hand-bound sketchbook 26.75 x 25½ cm (10½ x 10 in.) Collection of the artist
Among the more permanent objects in my studio, the sink and the wood-burning stove have been the subject of a number of works. I suppose they are iconic symbols of my workspace, and themes that I don't think I have exhausted yet.

Kitchen Window

Rotring Rapid PRO 2.0 clutch pencil with 4B lead, Green and Stone sketchbook 30 x 43 cm (12 x 17 in.) Collection of the artist
I liked the size of this sketchbook, bought on a trip to London, which was different in scale to those I have had in the past. I used it here to work out a number of compositional ideas for still lifes. The smooth paper lends itself well to pencil work but is too light in weight for watercolour.

This is one of those drawings where I enjoy taking the pencil for a walk and I don't get overly concerned if things aren't exactly in the right place or correctly proportioned. I start at one point and let the drawing grow outwards. This can often lead to an exciting composition or something unexpected happening, which causes other ideas to feed into the work.

Studio Sink and Yucca Plant

Faber-Castell Clutch pencil 6B lead ,Hahnemühle D&S Sketchbook 30 x 22 cm (30 x 8½ in.) Collection of the artist
This is an idea that I have been thinking of developing into a large painting for a while. With this version I had put a yucca plant into the sink in order to water it, and then thought it would make an interesting image to paint, so I began by doing various sketches from different angles, plus a few colour studies. The final piece is still a work in progress.

Owl and Studio Interior

Faber-Castell Clutch pencil 6B lead, Hahnemühle D&S sketchbook,
30 x 22 cm (30 x 8½ in.) Collection of the artist
Drawn from the mezzanine level of my studio looking down on the ever-changing clutter of the studio floor, and using the device of the owl on the shelf to create scale and distance in the painting; the first version of which appears on the opposite page.

Studio Interior

Watercolour, Berol Karismacolor water-soluble pencil, oil pastels, Saunders
Waterford 300 gsm NOT paper 53 x 71 cm (21 x 28 in.) Collection of the artist
I included the owl as a large foreground motif in order to give the feeling of scale and distance in this work. It was drawn from high up on the mezzanine floor of my studio, looking down into the main part of the work area. The juxtaposition of the large and small, near and far objects gave a dynamic feel to the composition, which I rather liked.

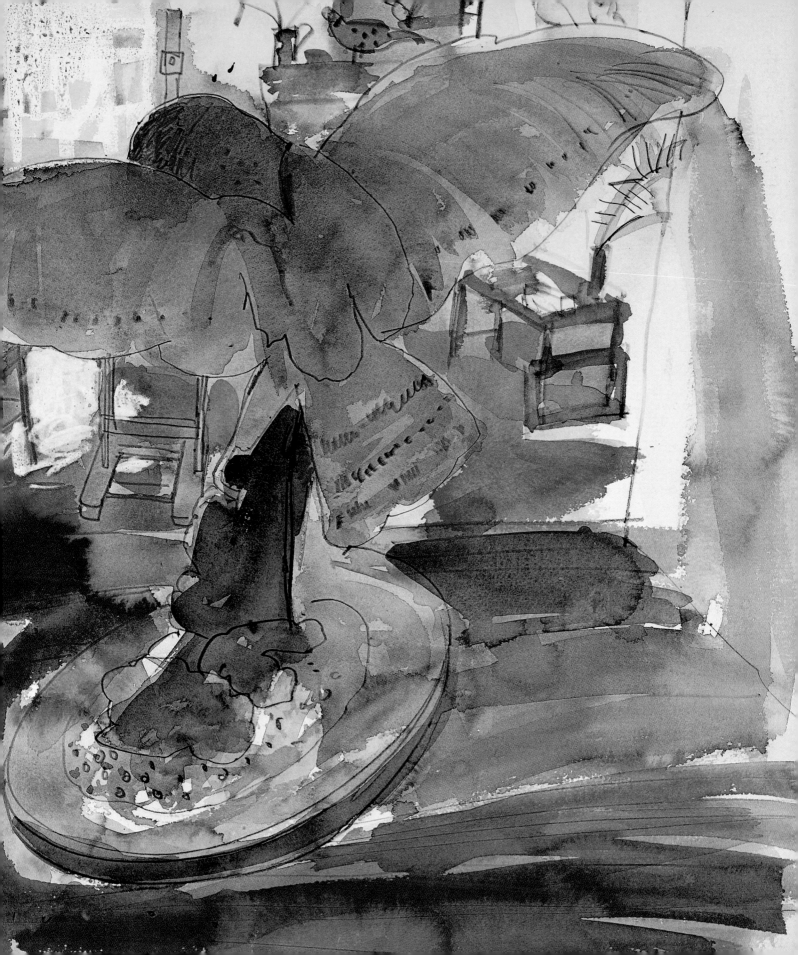

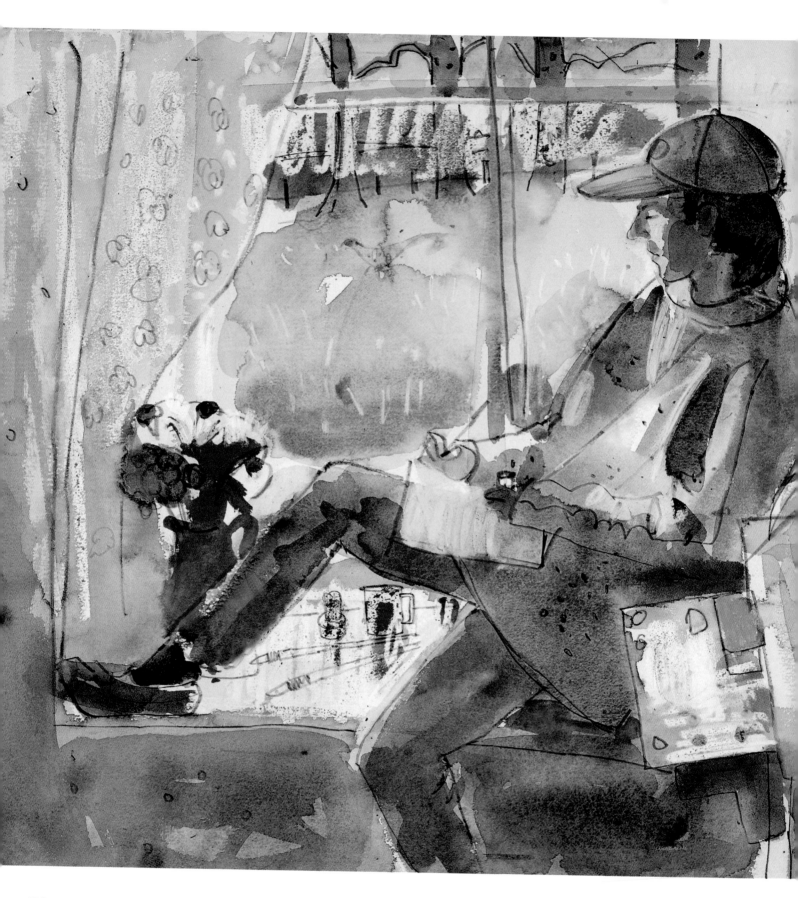

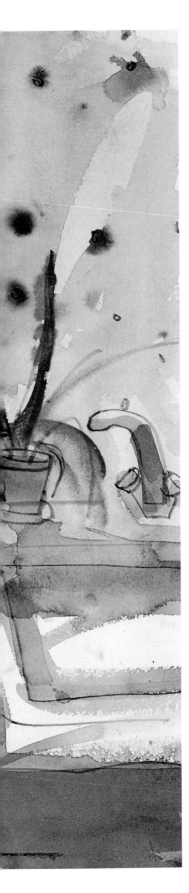

Dreaming

Watercolour, Berol Karismacolor water-soluble pencil, oil pastels, Saunders Waterford 300 gsm NOT paper 53 x 71 cm (21 x 28 in.) Collection of the artist

An informal portrait of Kim, my eldest daughter, caught doing a drawing of the landscape outside the rented farmhouse where we lived for nearly two years. She had – and still has – a knack of 'borrowing' my stuff; here she is wearing an old painting smock of mine and no doubt is using drawing materials purloined from my studio. The title refers to her dreaming about starting her first year at art school after the summer holidays. I recall that there was a pheasant, which ran across the field outside our cottage, and you can just see it in my painting.

Red Table and Owl

Watercolour, Berol Karismacolor water-soluble pencil, oil pastels, Saunders Waterford 300 gsm NOT paper 18½ x 22 cm (7 x 8½ in.) Private collection

During the course of a normal week in the studio, things get moved around. Jugs, vases and so on are often borrowed by my wife Carol for flowers in other parts of the house, or plates and other items go walkabout. When returned, they are never put back in the same place: this can often lead to an interesting accidental still life. With this small painting, all I did was add some flowers in a jug before painting it with this strong arrangement of almost primary colours.

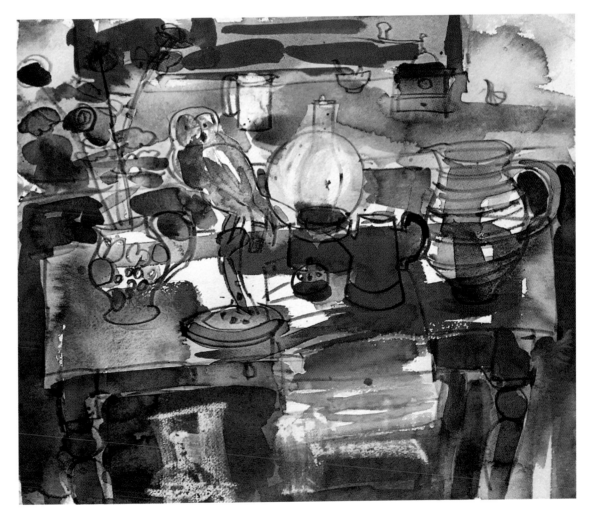

Nature Table, Spring Light

Watercolour, Berol Karismacolor water-soluble pencil, oil pastels, Arches Rives paper 300 gsm NOT paper 84 x 84 cm (33 x 33 in.) Collection of the artist

One of the drawbacks of drawing with a pencil into wet, puddled paper is that, more often than not, the paper will be slightly 'coggled', with rivers and valleys of undulating water and pigment making the drawing of a dead straight line rather difficult to achieve. While this can be infuriating, I have learned to accept it and to just go with the flow. Hopefully the finished painting will work as a whole – straight lines or not. This watercolour is a typical example. There are few straight lines and it was made more difficult to achieve them by the scale of the painting, which was worked on flat (as always), making it hard to reach the top part of the paper.

A photograph of me painting in the studio against a background of some of the still life objects I have gathered over the years.

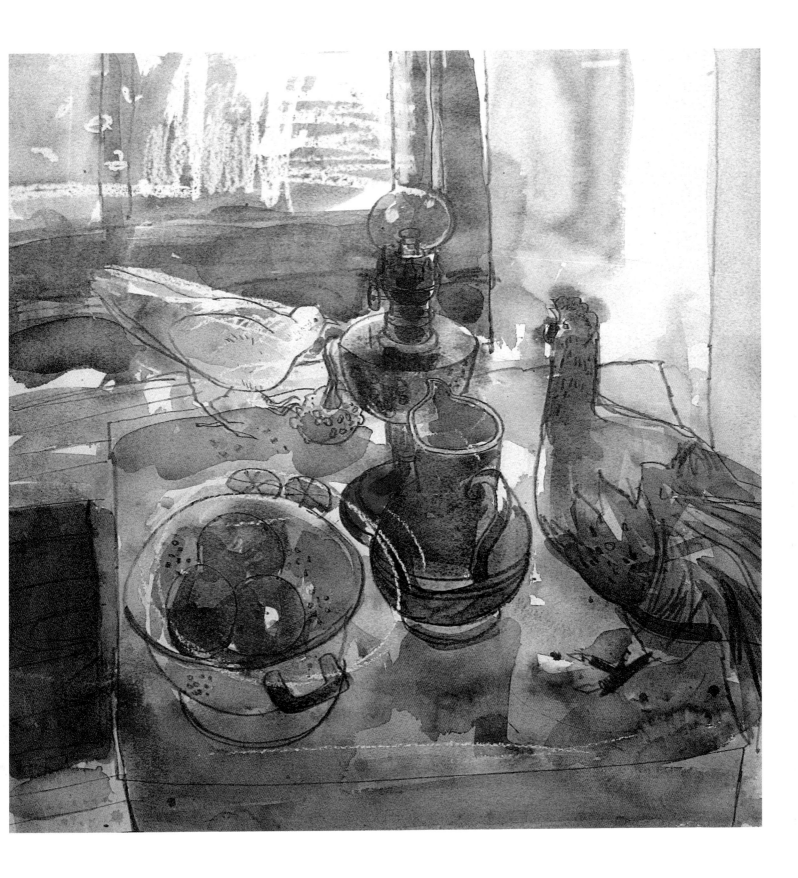

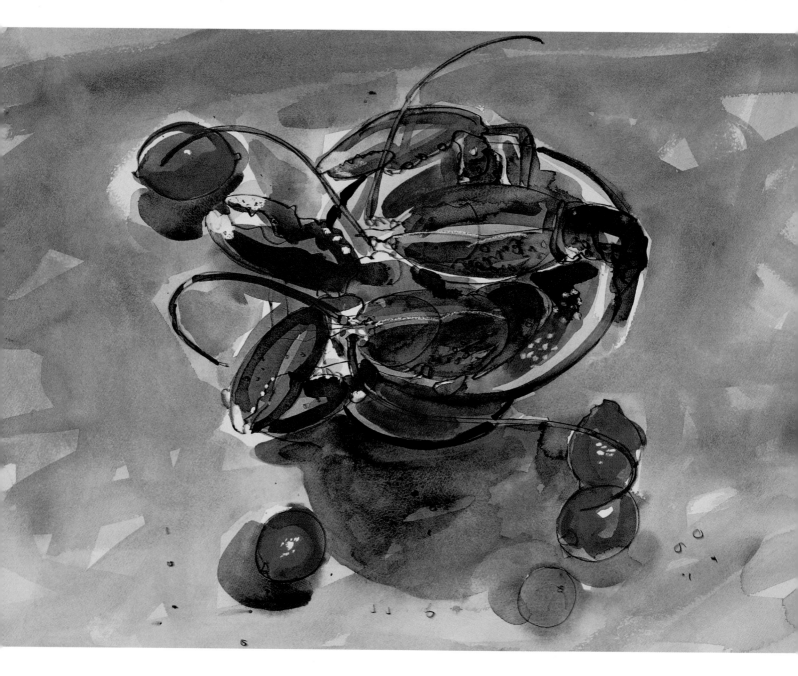

Lobsters, Lemons and Lime

Watercolour, Berol Karismacolor water- soluble pencil, oil pastels, Waterford NOT paper, 53 x 71 cm (21 x 28 in.) Collection of the artist.

The colour of lobsters always intrigues me. Each time I cook them, they seem to turn out a different shade of red; anything from a dusty pale pink through to a deep, saturated vermillion. I'm told it's all about the weight of the lobster and the length of time in the pot. I suppose there is a strange analogy with watercolour painting. No two washes are ever the same, no two glazes will have the same effect; the more something is over-glazed, the more dead or over-cooked it will appear. So I suppose if there is a 'recipe' here at all it is simply to have a light touch and don't over work (cook) it too much... getting this delicate balance just right is the answer to a successful painting!

Glossary

artists' colourmen – an old-fashioned term to describe manufacturers or purveyors of artists' pigment and materials.

Berol Karismacolor water-soluble pencil – an American-manufactured pencil sadly no longer in production. Derwent and Caran d'Ache also make good pencils of this type.

block in – arranging major elements of a painting using simple tone, shapes, colours and forms when beginning a watercolour painting.

Chinese white – a white watercolour made from zinc, and as such it is relatively weak and transparent, ideal for rendering highlights in watercolour.

Conté crayons – also known as Conté sticks, these are a drawing medium composed of compressed powdered graphite or charcoal mixed with a wax or clay base, usually square in cross-section.

Conté pencil – basically the same as Conté crayons except made in the form of a pencil.

clutch pencil – a mechanical pencil or a propelling pencil is a pencil with a replaceable and mechanically extendable solid pigment core called a 'lead'. The lead, often made of graphite but also with compressed charcoal, is not bonded to the outer casing, and can be mechanically extended as its point is worn away. Has the advantage of not having to constantly sharpen the point as with a normal wooden-cased pencil.

coggled – paper becomes 'coggled' when a lot of water is used in a painting, the paper becomes saturated and expands, creating rivers and 'valleys' on the surface. When dry it , if stretched, will usually become flat again.

compressed charcoal – charcoal powder mixed with gum binder compressed into round or square sticks.

contre-jour – French term meaning 'against daylight'. Painting against the light usually hides details, causing a stronger contrast between light and dark.

Golden section – also known as the divine proportion, golden mean, or golden ratio, is a number often encountered when taking the ratios of distances in simple geometric figures and used by artists to determine the ideal composition.

granulation – certain pigments we use are granulating, which means that when water is added the pigments separate from the binder and settle into the valleys of the paper. As it dries in the valleys it leaves a grainy texture.

Kolinsky sable – hair brush – also known as red sable or sable hair brush. The hair is obtained from the tail of the Kolinsky (*Mustela sibirica*), a species of weasel rather than an actual sable.

mid-tone – the tones in a painting which lie between the highlights and the darks.

mid-value – similar to above, it is a depth of shade that is in the middle between the light and dark extremes of a particular colour.

mop brush – a large brush which can hold a lot water. Mainly used for quickly laying in colour washes over a large area.

NOT paper – watercolour paper comes in three basic types. NOT, meaning not hot-pressed, is slightly textured with a medium 'tooth' when compared to HP or hot-pressed (smooth) and rough (very textured). NOT (also referred to as CP) falls in between. Cold-pressed paper (NOT) is smooth enough to render soft blending, yet allows for textural effects and granulation in washes.

over-drawing – drawing on top of a painting that has either dried or is still wet in order to emphasize or correct elements within the painting.

over-glazing – used in watercolour to lay a wet wash on top of a dry wash to create a certain colour effect.

en plein air – or *plein air* painting, is a phrase borrowed from the French equivalent meaning "open (in full) air". It is particularly used to describe the act of painting outdoors in the open air.

primary colours – these are colours that cannot be created through the mixing of other colours. They are colours in their own right. The three primary colours are red, blue and yellow. Primary colours can be mixed together to produce secondary colours.

Rigger brush – a brush with long hairs and a fine point often used for detail work and fine lines.

spotting scope – a telescope usually mounted on a tripod.

stretching paper – this method is used to achieve a perfectly flat surface on which to paint. It is achieved by soaking the paper and the brown gummed tape used to retain the edges. After laying it on a board, excess water is sponged off and when completely dry the paper and tape will have shrunk slightly to a drum-tight surface perfect for painting on. If a heavyweight paper is used then dry stretching, using a good quality masking tape, can be used as an alternative.

under-drawing – a technique used to indicate the placing of objects within a painting, usually drawn lightly with a pencil. Can also be used in a more graphic way eg., by using a fibre-tip pen or Indian ink for the under-drawing and when this is dry, using watercolour to fill in all or some of the outlined areas.

vellum-surface paper – vellum was originally made from calf skin but modern paper vellum (vegetable vellum) is a quite different synthetic material, used for a variety of purposes, including plans, technical drawings, and watercolour.

wax resist, or oil resist – a technique used in watercolour painting based on the premise that water and wax or oil can't be mixed. A candle or oil pastel is drawn on the paper, surface, a colour wash is then laid over this and where the wax or drawing was made will resist this and the wash will soak into the paper surrounding the waxy marks.

wet-into-wet technique – a spontaneous way of working whereby a wash of colour is laid on top of an area of colour that is still wet. Different effects can be achieved depending on how wet the underlying wash is. Also, it is a way of mixing colours on the paper.

Index